best wishes
Macy

Taking a Leaf out
of the Good Book

Tracy Spiers

Spotty Flamingo Publishing
8 Milton Grove, Stroud
Gloucestershire, GL5 1NP
An imprint of Tracy Spiers Illustration
www.tracyspiers.co.uk

British Library Cataloguing in Publication Data.
A catalogue record for this book is available
from the British Library.

ISBN 978-1-9998486-3-7

Typesetting and origination by Tracy Spiers

Spotty
Flamingo

I want to thank Kim Newbould, Colin & Mary Andrews, Ian & Ali Rimmer, Lisa, Denise, Joan, Chris and Lorraine for believing in me and for investing in Spotty Flamingo and helping my publishing vision to fly. To all those who encouraged me to have the confidence to put this book together, Thank you to Poppy Robertson for her technical assistance and to David Powell and his team for his expertise and for printing my leaf characters.

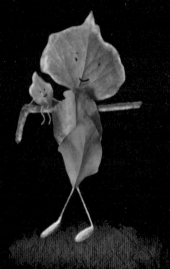

Thank you to my wonderful husband Rog and our precious daughters Naomi, Emily, Megan, Rosie and Kezia for your love and support.

I hope you all enjoy seeing the collection together as a whole. I have grown quite fond of my leaf folk as they have brought Scripture alive.

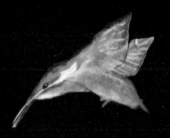

In loving memory
of Gill Spiers

Inspiration

Growing up, I used to enjoy playing with felt shapes which could be rearranged to create different pictures and characters. *Fuzzy Felts* was a favourite pastime long before modern technology was even thought about.

A few months before this book began, I was chatting with friends and mulling over life when one of them said *"we need to take a leaf out of the Good Book."* That phrase stayed with me.

As I walked home one day, I started picking up colourful and irregular shaped leaves that caught my eye. That same phrase popped into my mind and as Lent was approaching, I decided to start a series called *"Taking a Leaf out of the Good Book"* by using the leaves I collected to create different scenes with a daily message.

It was my last walk for a long while, as I fractured my heel a few days later and had to stop running, walking, driving and literally became immobile. I experienced my own lockdown before COVID-19 forced the nation and indeed many nations into standstill.

As a mother of five daughters - including twins - one of my favourite Bible verses comes from Proverbs 31.

In verse 25 it says: *"she can laugh at the days to come."*
The gift of humour has helped me through many moments.
I remember well the logistics of getting five children under
the age of 7 out of the house in the mornings. It required
creativity and the ability to laugh in order to get through the
day.

As a writer and illustrator, I wanted to use my skills to
encourage others during Lent. So with my playfulness, love
for colour and fun, I endeavoured to unpack Scripture in a
fresh way. I can not take credit for the amazing verses from
the Bible which are God-breathed and full of wonderful
truth and life, but instead count it a privilege to be able to
illustrate what is already there. My prayer is that my words
and pictures will help shed some light and help you
discover for yourselves what treasures there are within the
Good Book.

As Lent rolled into lockdown, I decided to carry on and the
series finally concluded on July 4 2020, Independence Day,
a day when non-essential shops were allowed to open in a
bid to kickstart the High Street economy. This book
therefore is a record of what is a significant season in
history - and yet I hope the truth of the words will continue
to inspire for many years to come.

Tracy Spiers

Day One

"Where you go, I will go."
Ruth 1: 16

We all need a friend to walk beside us and love us in the good and bad times. This verse is found in the Book of Ruth, referred to sometimes as the Cinderella of the Bible because it is a rags-to-riches story. It is also an example of strong and loyal relationships. Here we see two widows Naomi and her daughter-in-law Ruth who are joined by love.

Determined to walk through the dark valley with her mother-in-law and be her companion despite her own pain, Ruth declared that wherever Naomi went, she would go. That meant leaving what was familiar and the god of her family, Chemosh, to follow and trust Naomi's God, Yahweh. Naomi lived out her faith with kindness and it touched Ruth so much she wanted to seek after Naomi's God.

The whole Book of Ruth is about trust. It is a beautiful story which inspires and motivates us into deeper faith, steadfast love and hope. Just as Ruth promises to go where Naomi goes, so God promises to do the same for us.

"I am fearfully and wonderfully made."
Psalm 139:14

Day Two

"I am fearfully and wonderfully made."
Psalm 139: 14

We are all wonderfully unique with a treasure trove of gift and talents. But often we don't know what they are until someone else points them out or encourages us.

Sometimes we need to dig deep to uncover what lies within us. God made you and I and He has a special purpose and plan for us. The Bible says He formed us and created us as His own masterpiece.

It's only when we understand the greatness and truth of this verse that we can be free from so many negative things that keep us from serving God.

When we are true to ourselves and allow the uniqueness of our personalities to shine, then we can make a difference. Don't be afraid to stand out and be everything that God intended you to be - even if it means going against the flow of the world and being different.

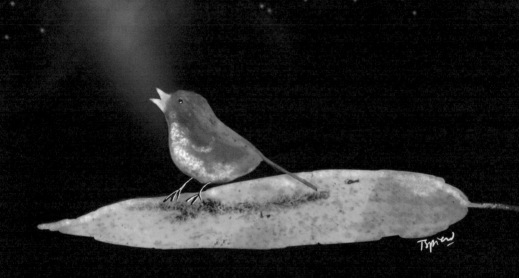

"I sing through the night."
Psalm 63:7

Day Three

"I sing through the night." (TPT)
Psalm 63:7

When I was pregnant with our third daughter, the midwife couldn't find her heartbeat and I had an emergency hospital appointment the following day to see if she was alive or not. It was one of my darkest nights. I cried out for her little life and prayed all hours, claiming scriptures and standing on them in worship. Yet I also said I would still believe and trust even if it was not the news I wanted.

When I saw her tiny hand waving on the ultra-scan, I cried for joy. We all have dark times but we have to remember that even though we may not feel it, we are not forgotten by the one who hears us in the silence.

Worshipping in the good times is easy; it takes courage and faith to raise our voice in the tough times. Let us remember when we are going through the night time of the soul, to lift up our voices, knowing with confidence that the Lord hears us.

"Be joyful in hope." Romans 12:12

Day Four

"Be joyful in hope."
Romans 12: 12

In life we hope for many things, we hope for good weather, a parking space, good health or good results. But our hope is only as strong and reliable as our source. There are times when we struggle with hopelessness and no matter what the situation we face, we all desperately need *hope*.

It is more than a motivational thought, it is powerful. Hope has been described as something which stabilises our frantic thoughts and emotions. It is coming to the realisation that God is bigger than the problem or worry facing us.

We can hold on to hope despite our circumstances. There are times when physically we can't jump. I write this with a fractured heel, but I choose to jump for joy inside because my Hope is real and alive.

" Let love and faithfulnes never leave you. " Proverbs 3:3

Tspicy

Day Five

"Let love and faithfulness never leave you."
Proverbs 3: 3

Being faithful is so important not only in our relationships, but in our work place, community and life. Years ago I learnt a dance to a song called *Faithful*, which explained that just as the sun rises every morning, so is the faithfulness of our God.

The word faithfulness is highly regarded in Scripture. It is listed as one of the 'fruits of the Spirit.' Mother Teresa once commented, *"I do not pray for success. I ask for faithfulness."*

We need to be faithful to God's calling, faithful to His promises and faithful to His message. He is faithful to us even when we are faithless. He gives us the greatest example of how to be in our own relationships - in marriage, in our friendships, family and ultimately with Him. And even when others are unfaithful to us, He will always be faithful.

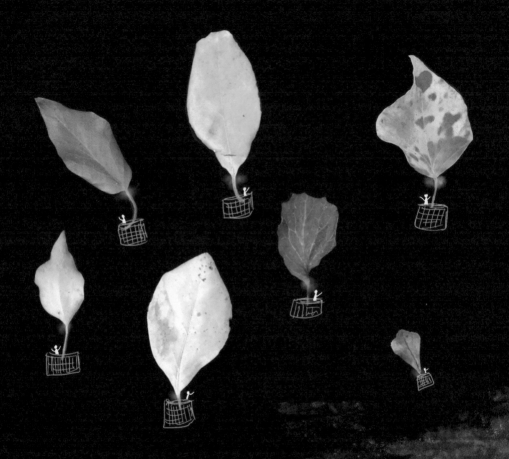

"I lift up my eyes to you." Psalm 123:1

Day Six

"I lift up my eyes to you."
Psalm 123: 1

In the summer when the weather is favourable, hundreds of balloons in all their wonderful shapes and colours take off over Bristol for the city's annual balloon festival. It really is an amazing spectacle.

In the evening there is a night-glow, whereby some balloons are tethered and those watching see what resembles giant fireflies. In life there is so much negativity which can drag us down, and we are prevented from flying as high as we potentially could.

At times we feel tethered and can not seem to cut the strings to enable us to fly free. Sometimes we try and fix problems with our own strength and hold on too tightly. But if we choose to look up, then we can have a lightness in our spirit and see things from a different perspective. We can also give others a ride too. Look up today and trust the fire within you to lift you above negative emotion and disappointments.

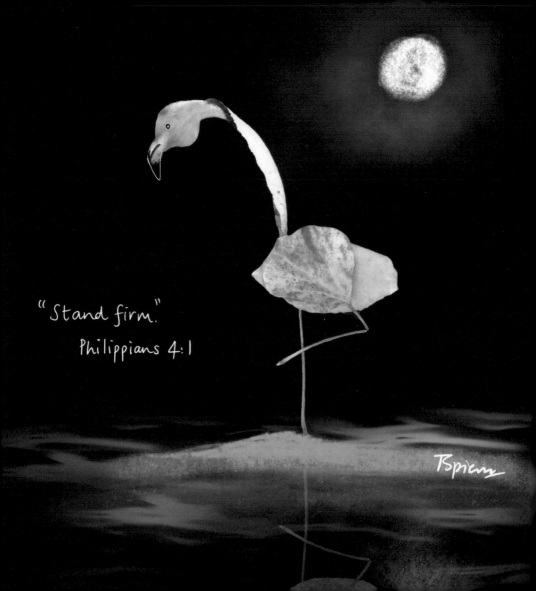

"Stand firm."

Philippians 4:1

Day Seven

One of my favourite bedtime stories as a child was a tale about a boy called Geoffrey who turned into a flamingo! These funny creatures have always fascinated me. I love their quirky nature, the fact they can stand on one leg for hours and hours and they stand out because they are so different. The word *'flamingo'* comes from the Latin and Spanish meaning *'fire'* which I guess refers to their bright pink feathers. I associate fire with passion. Flamingos also have the ability to run on water before they take off and fly. They love flying as a community and they have one mate for life.

As I write this I am perfecting the art of standing on one leg (in a wobbly fashion) as I have a fractured heel and can not put it down. A flamingo makes it look so easy! The only way to stand firm, certainly on one leg, is to fix our eyes on one thing. It is so easy to feel wobbly in uncertain times. Let's fix our eyes on the author and perfecter of our faith - Jesus.

Day Eight

"Called to be free,"
Galatians 5: 13

There is something liberating about being on a swing no matter how old or young you are. However, you do have to hang on and trust the rope you're holding. How high you go depends on either how strongly the person is pushing you, or if you are on your own, how hard and efficient you push your legs.

The two key elements are trust and freedom. When they work together, it is then we can go to new heights in our faith. To live in God's freedom requires some decisions on our part. God doesn't force His freedom or goodness on us. We have to choose and receive it.

In life we can get let down by people which can leave us bitter or angry. But we can live in freedom if we choose to forgive and let God make it right. Let's decide to live the life we were always meant to live - rising above the negatives and enjoying the fullness of what God has for us. We have a choice. Let's choose freedom.

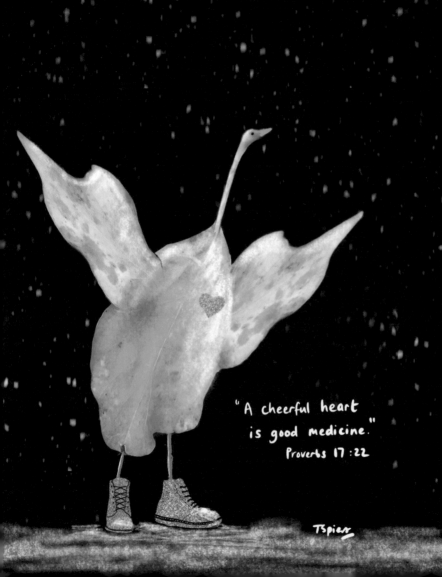

"A cheerful heart
is good medicine."

Proverbs 17:22

TSpier

Day Nine

"A cheerful heart is good medicine."
Proverbs 17: 22

We can turn a tough or bad day round if we determine to keep a good attitude. I find the best medicine is humour and being grateful for the simplest things. And who wouldn't feel joyful in a pair of gold sparkly DM boots?

I got married in a pair of white Doc Martens after noticing that the Pope was wearing a pair on a television documentary. As I am not good at walking in high-heeled shoes, I thought the safest way of walking down the aisle *and* gaining an extra inch was to wear the white boots. They have become a very good friend over the years and my daughter who has inherited my 5ft height, has also inherited my love for the DM boot. Our cupboard is full of various colours, including a gold sparkly pair like my leaf bird is wearing.

I believe that God has a sense of humour - after all He designed us to laugh. We just need to learn to be a little less serious and laugh at ourselves sometimes.

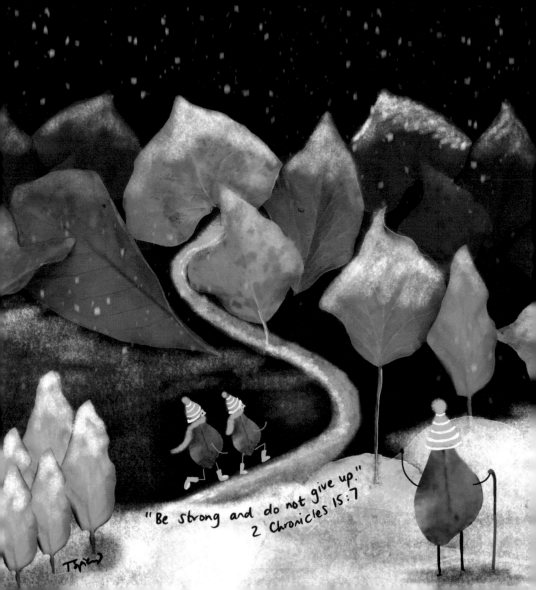

"Be strong and do not give up."
2 Chronicles 15:7

Day Ten

"Be strong and do not give up."
2 Chronicles 15: 7

We are all at different stages in our life journey. Some have travelled many hills and valleys and have gone before us. Sometimes we see the mountain-top views, whilst other days we experience the confusion of fog and poor visibility.

Yet in all this we are encouraged not to give up. We need each other. I often think of the words of the song, *Up Where We Belong,* when venturing up a hill. Love *does* lift us up where we belong, where the eagles fly on the mountains high. We all get weary when we climb and yes there is always a journey ahead of us. But we have to stop and appreciate the view where we are now and remember how far we have come.

We may not be at our final destination yet, but we can enjoy the journey and the company we keep. Today, let's spur a fellow traveller on.

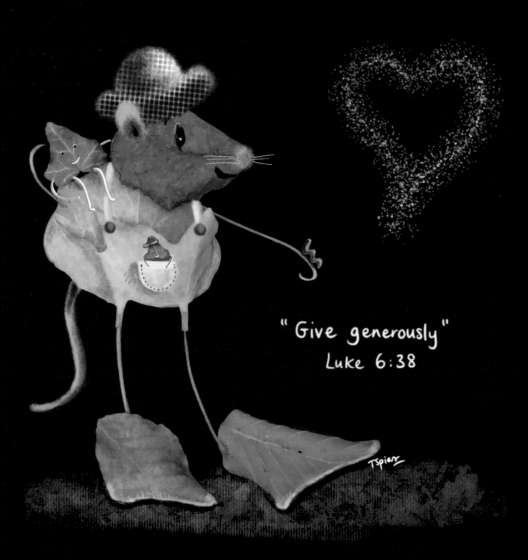

Day Eleven

"Give generously." (TPT)
Luke 6: 38

In this 'selfie' generation, it is refreshing when others do selfless acts of kindness for us or our loved ones. Our culture is an incredibly selfish, self-centered, self-gratifying and self-promoting one. But in the kingdom of God, the little things are the big things.

By the little things I mean the things that are done when no-one else is looking. It may mean clearing up after someone who isn't aware they have made a mess, or paying someone's bill and not telling them.

We may not necessarily have money to give away but we do have time, gifts, talents and love to share. Even a smile, a compliment or a thank you can brighten up someone else's day.

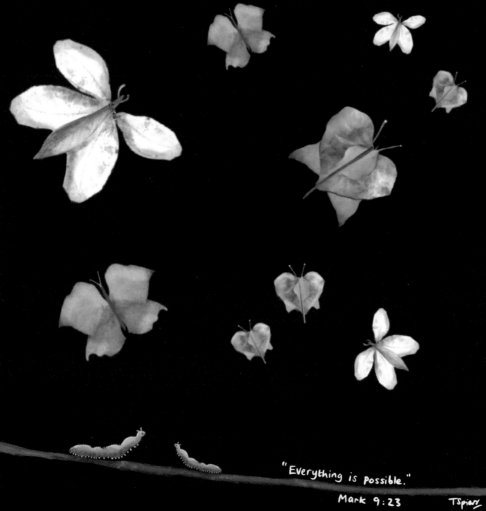

"Everything is possible."

Mark 9:23

Day Twelve

"Everything is possible."
Mark 9: 23

I am always fascinated at how a little caterpillar can turn into a beautiful butterfly. But I also know there is a tough process to go through in between. The chrysalis must feel like a dark, tight space compared to previous freedom. It is a wrestling time during which the wings get strong. It is hard watching someone you love go through a painful process. Everything in us wants to rescue them and save them from pain. But to do so is detrimental to their ultimate freedom. If we pull a butterfly-in-the-making out of the chrysalis before it is ready, it will die.

There is a time for everything and individuals will emerge eventually, stronger for the wrestling process. While I write this, my teenagers find it amusing seeing their mother literally crawling and bum shuffling around the floor as I wait for my fractured heel to heal! But I know I am not destined to stay there. I will fly (or perhaps I should say run) again. Don't settle on being a caterpillar, be prepared for a journey so that you can get your wings and fly.

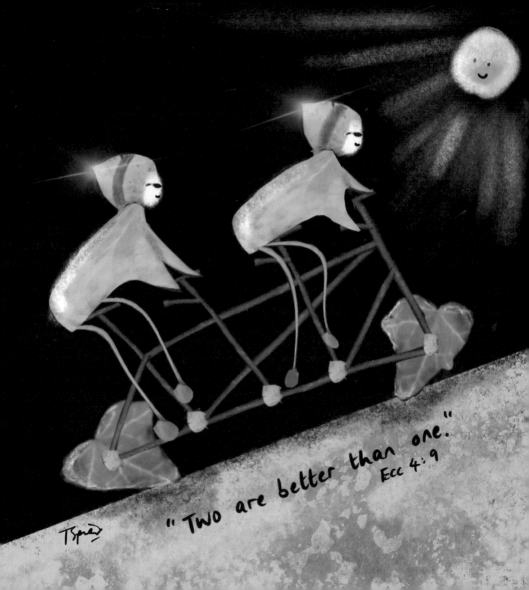

Day Thirteen

"Two are better than one."
Ecclesiastes 4: 9

I am not sure the wheels of this bike will take them far, but it is teamwork that matters. When we are climbing a hill in life, it doesn't feel as steep if we have a companion. We can achieve our dreams when we work with like-minded souls who want to help them become reality.

We can walk through life on our own, but we were designed for fellowship with those around us. My husband has been training hard for the Coast to Coast challenge from Whitehaven to Sunderland to raise money for Motor Neurone Disease Association in memory of his lovely mum Gill, who died of this cruel disease earlier this year.

He has been spurred on not only by his team mates and family but those who have faithfully and generously donated to raise an amazing £5,800. We all need each other.

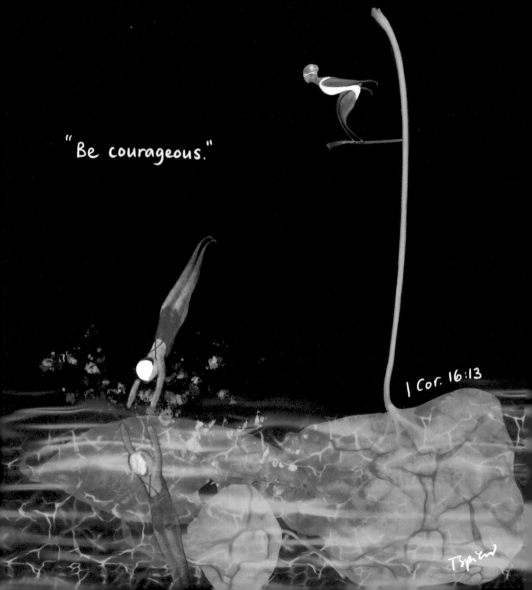

Day Fourteen

"Be courageous."
I Corinthians 16: 13

When we face anything new, uncertain or embark upon unknown territory, it is easy to let the shadows of our fears overwhelm us. I went to university in my mid 40s.

I was daunted by all the modern technology and felt like a fish out of water - or should I say an ancient fish, as I was over 25 years older than my fellow students. I went on and did an MA in illustration and ended up being awarded a prize for the highest achieving student.

If I hadn't faced my fears, I wouldn't have gained what I needed for this new journey I am on. What kept me going was believing that if God wanted me do it, He would give me everything I needed to do it.

Sometimes we just have to feel the fear and do it anyway. If there is something you need to do, just go for it, be brave and take the plunge. There's a fresh and exciting adventure awaiting you.

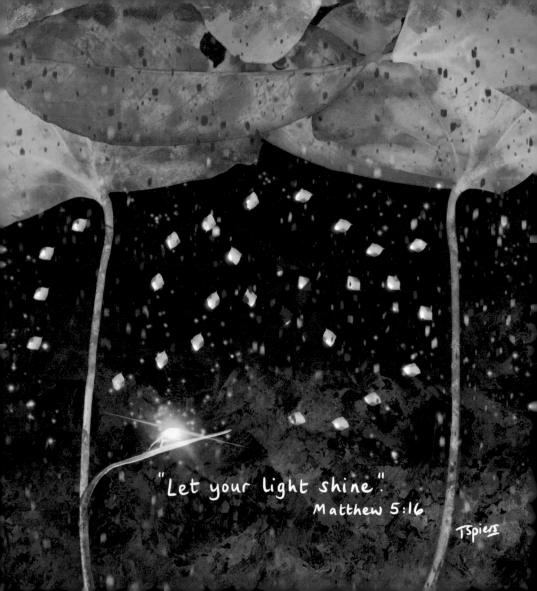

"Let your light shine".
Matthew 5:16

TSpiers

Day Fifteen

"Let your light shine."
Matthew 5: 16

In this surreal and strange time we are in, lots of people are concerned and will feel isolated. Let us determine to look out for those who do feel vulnerable and bring a bit of light into their darkness.

In the Bible, Jesus is described as the Light of the World and came to bring light and hope into our darkness. If we believe in Him, we too can carry His light. Fireflies may be tiny but together they produce a wonderful spectacle of light. There are more than 2,000 species of fireflies, which are a type of beetle. As a creature of light, the firefly is a symbol of illumination.

During the daytime hours they are ordinary and nothing spectacular to look at. In the dark however, they are majestic and quite extraordinary and some can even synchronise their flashing. We may feel insignificant, but when we shine our light in places and situations that are dark, we too can have an amazing impact.

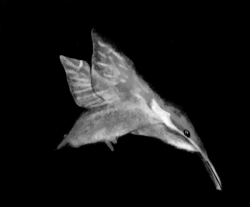

"Be prepared."
Ezekiel 38:7

"Swim faster chaps!"

Day Sixteen

"Be prepared."
Ezekiel 38: 7

In order to see a kingfisher close up you need to be prepared to be patient. Most of the time it is a case of seeing a flash of blue. To survive, a kingfisher has to consume its own body weight in fish every day. In the UK, there is only one kind - the common kingfisher. Worldwide there are 87 species, the largest being Australia's laughing kookaburra, which weighs 15 times more than our bird.

All kingfishers have excellent vision and can see into the water. The kingfisher's beautiful, metallic blue and orange plumage stands out against the river banks, but more incredible is its swooping motion as it dives towards water to catch fish. As for the minnows it is hunting, they need to be prepared to swim pretty fast to get out of the way. As we face unusual circumstances, we need to be prepared, be wise yet not fearful. Perhaps we should also be ready like the kingfisher, to dive deep into Scripture and devour its words, which are described as *'living and active.'*

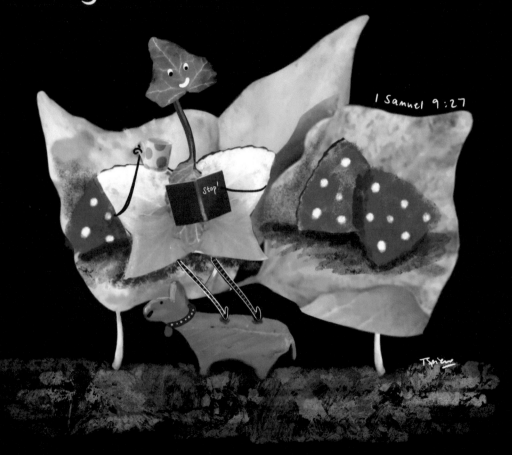

Day Seventeen

"Stay here awhile."
1 Samuel 9: 27

I am often running from one place to another, quite literally
and so often miss the detail of every day life - a new bud, an
unusual flower, a bird singing, a butterfly. Sometimes due
to injury, redundancy, illness or a deliberate choice, we are
forced to slow down and only then do we truly notice. We
are called to be still at times for a reason.

There is so much talk these days about mindfulness, which
basically means being mindful of the now moment.
One of the main reasons we are burned-out or so stressed is
that we don't really know how to be still. We are constantly
thinking of the next thing and don't value what we are doing
right now. We have forgotten to acknowledge God and we
don't really know Him as well as He wants us to.

It is only when we slow down and learn to be quiet on the
inside that we can live in a place of peace. Let's take this
opportunity to stop and consider what really matters.

"Share feely"
Deuteronomy 15:11

Day Eighteen

"Share freely." (NLT)
Deuteronomy 15: 11

I remember singing a song at primary school which referred to love being like a magic penny. It went something like this:

"It's just like a magic penny,
Hold it tight and you won't have any.
Lend it, spend it, and you'll have so many
They'll roll all over the floor.
Love is something if you give it away,
You end up having more."

One of the first lessons we are taught as children is to share. How quickly we forget when we fear we won't have enough. If there is a shortage of petrol, a certain type of food or product, it is easy to get into panic mode. It's then people start buying in bulk to such an extent that there is not enough to go round. Yet if we dare to share what we have, we get so much more back. We can never out give God, He has more than enough and longs to provide, if we will only trust Him.

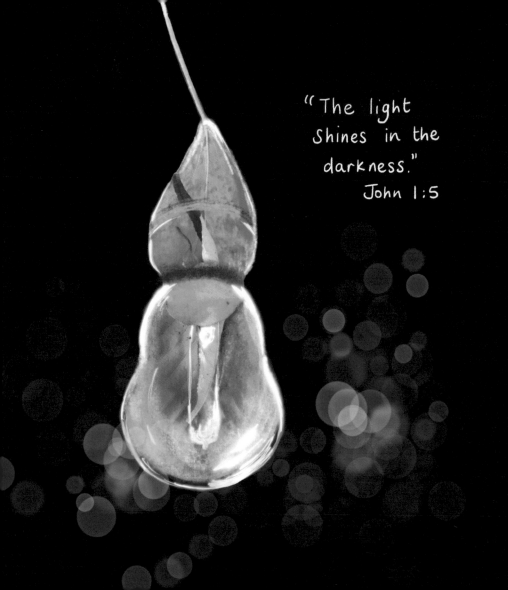

"The light
Shines in the
darkness."
John 1:5

Day Nineteen

"The light shines in the darkness."
John 1: 5

When our eldest daughter was very tiny, at bedtime she used to ask us to turn off the dark. If we're honest not many of us like the dark moments in life, when our fears seem to turn ordinary shadows into monsters and accentuated sounds scare us witless.

As we told our daughter all those years ago, we can't turn off the dark, but we can turn on the light. Understandably many people can feel frightened when what was normal is no longer. It may appear very black to some, especially if they live alone or they don't have loved ones nearby, so let us do our best to shine some light into their darkness.

A phone call, a text, a letter or a parcel sent with love and care can be the very thing which may help dispel some of the shadows that may linger.

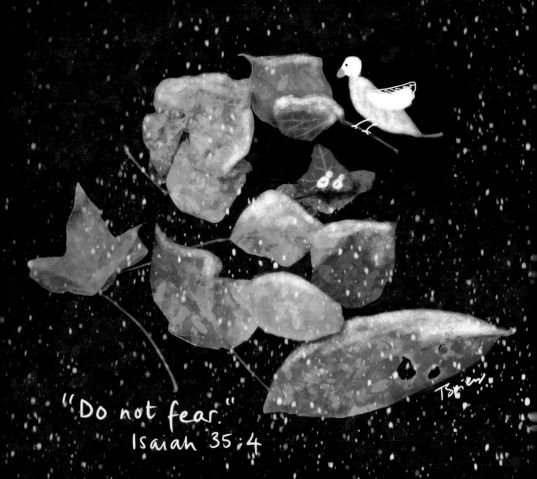

"Do not fear."
Isaiah 35:4

Day Twenty

"Do not fear."
Isaiah 35: 4

As I write this we are in the midst of a pandemic, COVID-19. Most of us have never experienced anything like this current state of surreal, confusing and worrying events. The whole world is being shaken and yet we are suddenly united in it - all of us impacted in some way.

As a cub reporter in the 1980s, I remember teaching my editor how to use a computer, because after decades of using a manual typewriter, he suddenly had to embrace modern technology two years before he retired. He had worked in newspapers all his working life, but suddenly his manual world was being replaced by a technological one. Within seven years the whole industry changed as computers took over.

We can all get shaken by change. But the Word of God, the Bible, doesn't change. It is secure and can be trusted. Its power and its promises are reliable and solid. We therefore have to believe that when we face uncertainty, we will be looked after and come through it.

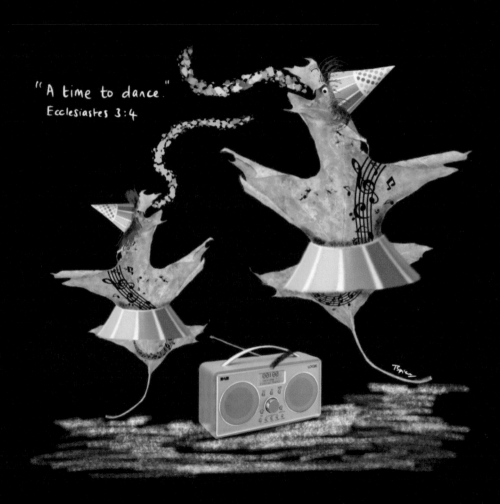

Day Twenty-one

"A time to dance."
Ecclesiastes 3: 4

Sometimes seasons change sooner than we envisage and we are caught by surprise. As I struggled to pick this leaf up with my crutches in the park, a 90-year-old came to my aid and insisted on helping me cross the road safely. That was enough to make my spirit dance.

When life throws something at us that we weren't expecting, it is important to try and be thankful, even if we have to dig deep. As I write this two of my teenagers are getting ready to leave school without exams, prom, a chance to say thank you to staff or have a proper celebration.

I have encouraged them to congratulate themselves for working hard regardless. Despite the circumstances, sometimes the best antidote is to do the opposite of how we feel - so let's dance (or hop) in my case.

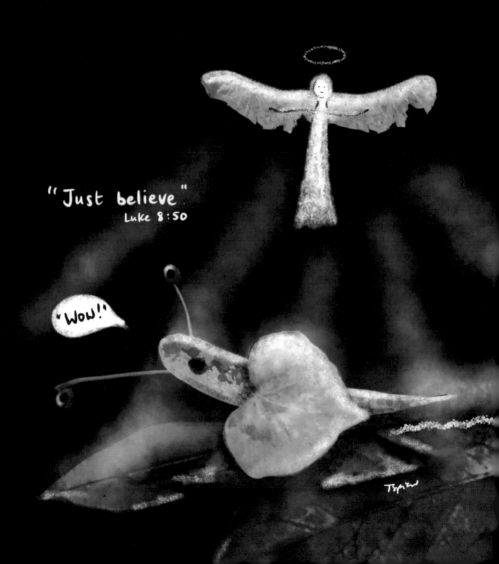

Day Twenty-two

"Just believe."
Luke 8: 50

I hope this generates a smile. This quirky startled snail character jumped out at me as I placed the leaves together. As I added my own touches, his personality came to life.

Understandably, we can feel rather stunned and alarmed when abnormal events happen, but I believe good will come from it. Every time you see someone help or encourage another, good is overcoming the bad.

It is also easy to get down by what we see in the physical, particularly when we read or hear depressing stories and headlines. We have physical eyes but in the Bible, the apostle Paul talks about a second pair of eyes.

He refers to the eyes of our heart which he prays will be *'enlightened'* in order to gain spiritual wisdom and revelation. To see with eyes of faith creates the *'wow'* factor in our lives no matter what the circumstances are around us.

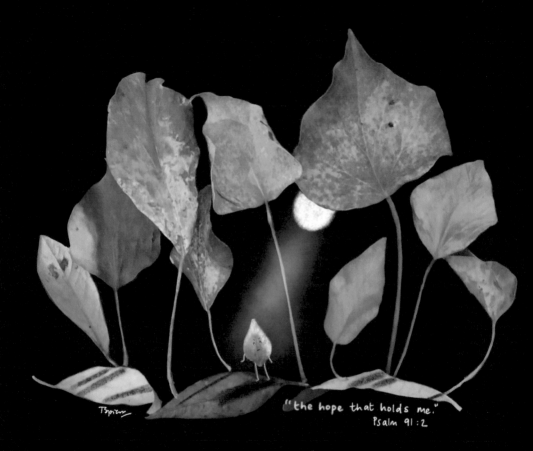

"the hope that holds me."
Psalm 91:2

Day Twenty-three

"The hope that holds me." (TPT)
Psalm 91: 2

When we are in a place where we have to do what seems unnatural and alien to us, it makes us face things we don't want to face - our own personal fears and anxieties. We are designed to live in communities so that we can support and look out for each other. We aren't meant to be isolated or have little physical contact.

The year 2020 will go down in history as a year when the world met with a strange hostile new environment. Yet it will also go down as a year when we were united in wanting to overcome something that potentially threatened us all.

I believe a seed of faith lies within each one of us and if we look beyond our fears, we will see it come to life. We all collectively need help through this surreal forest of shadows. There is someone who is bigger than a nasty virus or whatever scary situation that comes our way. And we can call on Him for help at any time.

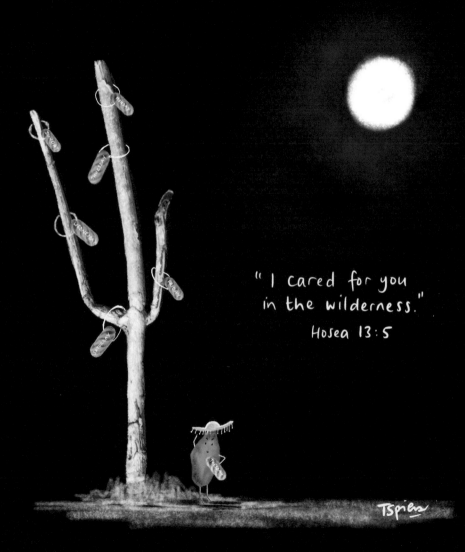

Day Twenty-four

"I cared for you in the wilderness."
Hosea 13: 5

COVID-19 has altered everything that was normal. Many of us face a wilderness, a strange, barren landscape that is unfamiliar. But I believe we will look back at this time and see how we were provided for and cared for in ways we never imagined. All of us have or will face other wildernesses in our lifetime. In the Bible, the Israelites faced their desert season. Yet despite being provided for every day, they moaned and groaned. Consequently, they ended up wandering around in the wilderness for forty years. It should have only been a short journey. Their state of heart was wrong. We have a choice. We can either be thankful or we can grumble. It won't change the situation but it will enable us to deal with it better if we have a positive attitude.

On this desert tree are loaves with each day of the week on. We have enough if we count our blessings each day. It may be a strange new land, but we can choose to be thankful for our daily provisions. We may not be able to control what happens, but we can determine how we respond.

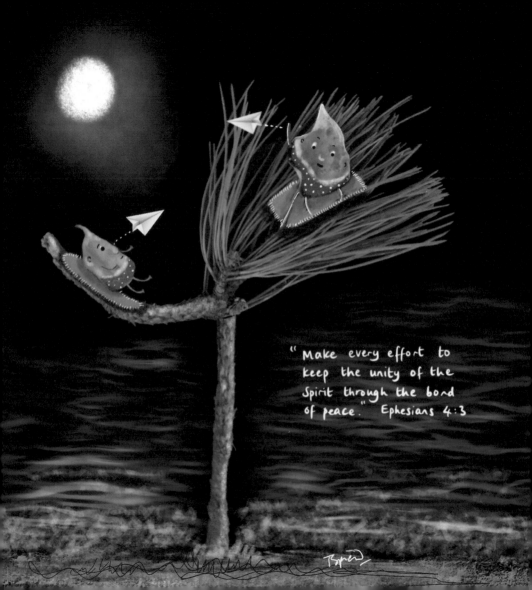

Day Twenty-five

"Make every effort to keep the unity of the
Spirit through the bond of peace."
Ephesians 4: 3

When my children were small, they took delight in creating imaginative worlds. One would pretend two pegs were people, another loved matching up buttons in the button tin, whilst those who didn't mind getting messy, delighted in making snow scenes with a gloopy mixture of water and cornflour. As the children grew up, I still encouraged them to be creative. As I pen this, I find myself isolated with two adult children, three teenagers and a husband. The aim is to get through each day as calmly as possible, refereeing personality clashes, seeking to reach out to those who need us, whilst doing what we have been asked without moaning.

Like these fun leaf characters, who find themselves cooped up in a palm tree (at a social distance) we are currently experiencing a lack of vapour trails in the sky. These two have decided to create their own planes to fly. When normal entertainment and leisure activities are removed, it forces us to be creative and resourceful - that has to be a positive. Creative activities due to their engagement factor, help us stay calm.

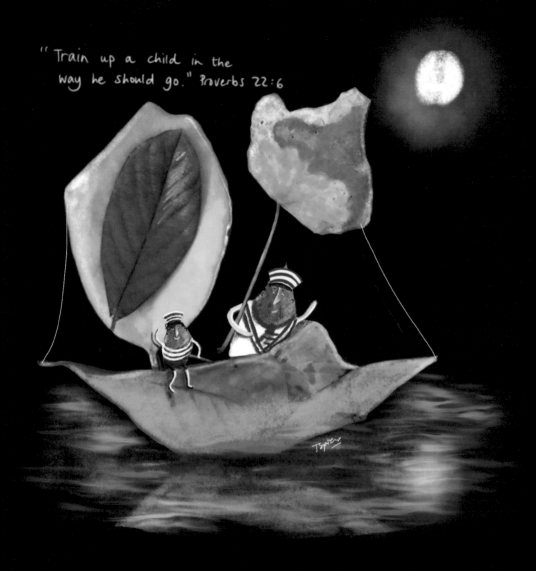

Day Twenty-six

"Train up a child in the way he should go." (NKJV)
Proverbs 22: 6

Whether we are parents, teachers, youth leaders or playgroup helpers, many of us will at some point have children in our care to encourage, teach or guide. I personally am so grateful to all those who have helped give my daughters a rich and rounded education - not only teachers at school, but those within family, church and community.

Children learn by being shown the way. They observe us, take note how we speak to one another and the way we treat others. One of our greatest purposes in life is to reflect God's image for our children to see. If we don't show them a Godly perspective, they will learn from other sources that may not be so good.

As I write, parents are now finding themselves in new roles as teachers and realising just how tough it is. Today let's acknowledge the teachers and praise God for their commitment, dedication and hard work.

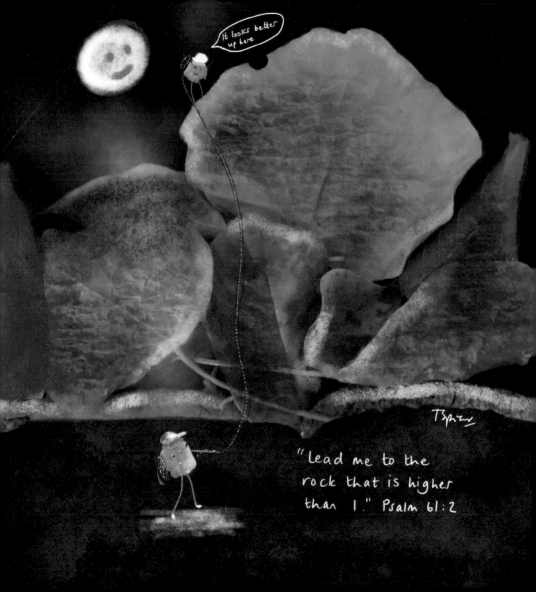

Day Twenty-seven

"Lead me to the rock that is higher than I."
Psalm 61: 2

I remember doing a musical production of *Pilgrim's Progress* when I was at primary school. It is John Bunyan's allegory of a Christian's journey or pilgrimage through life's difficulties to Heaven. Along the journey, the main character, Christian, finds himself in the Slough of Despond.

At times we can all find ourselves in a slough of despond. When we are walking through something, what makes it tough is not knowing when or how it will end and what the outcome will be. Sometimes the best question to ask is not why or when, but what? If we start looking at what we *can* do, we start lifting our head and have the ability to reach out and help when we ourselves are confused.

In *Pilgrim's Progress,* a man called Help gives Christian a hand and pulls him out of the pit and sets him on solid ground before bidding him on his way. I believe as we take our eyes off the situation we face and look up, we get *'strength for today and bright hope for tomorrow.'*

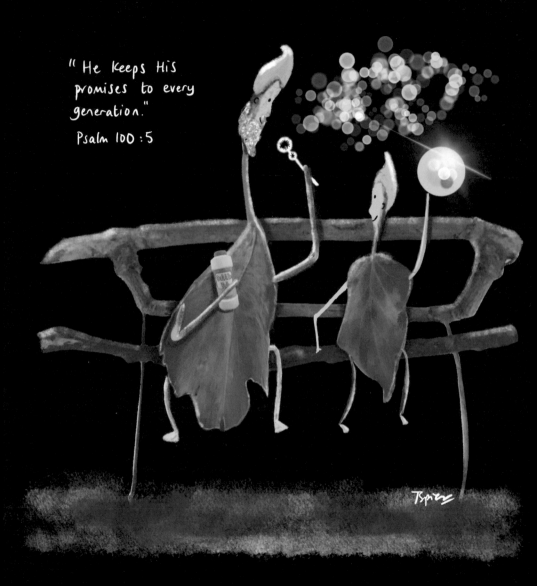

Day Twenty-eight

"He keeps His promises to every generation." (TPT)
Psalm 100: 5

There's something special about seeing relationships blossom between the youngest and oldest generations in one's family. I am truly grateful that my five girls have known all of their grandparents. My daughter Megan shares a birthday with my Dad. Normally the two celebrate together but as I write, due to my parents being over 70 and the inability to meet, it has to be from a distance. The pain of not being able to hug our loved ones is hard, but I thank God that we have them to love in the first place. Today I toast all the golden oldies for showing us how to live and love.

I think we are all having our buttons re-set to a simpler way of living - life before the rat-race - and that is no bad thing. This verse in Psalm 100 also reminds us of our own grandparents and ancestors who loved us. I pray that I will one day become a grandparent who invests in and shows God's love to my own grandchildren.

"You will keep in perfect peace those whose minds are steadfast," Isaiah 26:3

Day Twenty-nine

"You keep in perfect peace those whose
minds are steadfast."
Isaiah 26: 3

I have been thinking lately about how to stay calm in a
scary situation and how our fears and emotions go up and
down like a see-saw. Whilst there is something exhilarating
about being on a see-saw, it can make you feel seasick and
disorientated once you get off. It is also terrifying if the
other person suddenly disembarks!

Understandably our fears and emotions are going to go up
and down right now, but the best place to be is in the centre.
At the pivotal point of the see-saw is the centre of balance
and the ride is less rocky here.

Today, I believe the best place to be is still, concentrating
on what matters and putting faith back into our lives. It
changes our focus, perspective and gives us courage to stay
strong.

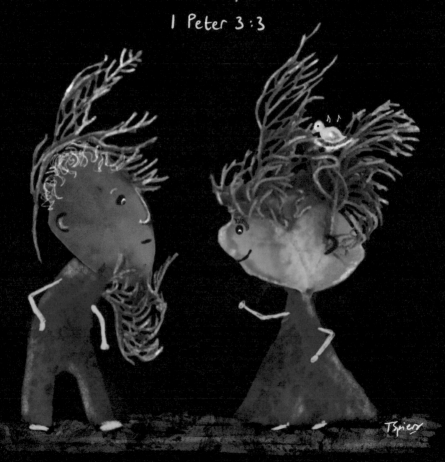

Day Thirty

"What matters is not your outer appearance - the
styling of your hair ...but your inner disposition." (MSG)
1 Peter 3: 3

So many of us over the years have at some point worried
about what we look like, how we dress and whether or not
we fit in. I used to dislike non-uniform days at school
in case I came in wearing something that wasn't trendy
enough. And as for hairstyles?

Well, I think 2020 will go down as the year of the wild hair.
Those fortunate to have a hairdresser in their house will be
fine, the rest of us, well, you might not recognise us at the
end of it! So today's message is about what really matters -
the heart not the hairstyle! Our hair might have attitude
and feel out of control, but we do have a choice over our
heart attitude.

Be kind to yourself, and allow yourself to laugh at the
wild-haired version of you in the coming weeks! And
hairdressers we miss you.

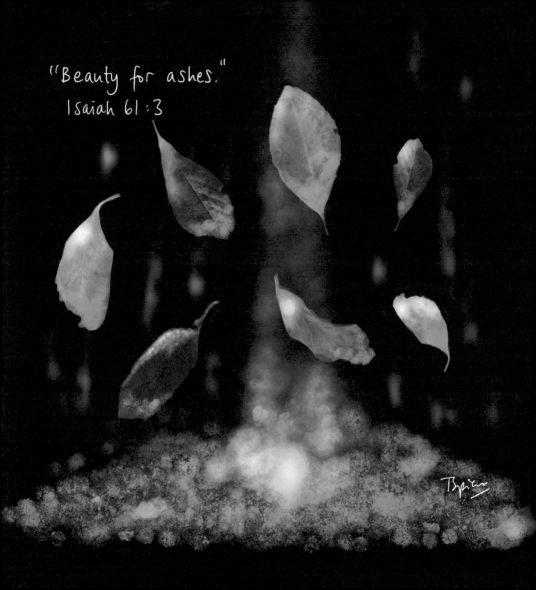

"Beauty for ashes."
Isaiah 61:3

Day Thirty-one

"Beauty for ashes." (NKJV)
Isaiah 61: 3

If we look back in history, it was customary for people to sit in or cover themselves with ashes to express mourning, loss, or grief over a national disaster.

The phrase *beauty for ashes* was a promise given to the people of Israel. Their land had been taken captive and people were feeling heavily oppressed. Isaiah spoke these words over them to give them hope in their dire circumstances.

I believe this promise is something we too can hold on to right now. Already beautiful gestures of kindness, compassion and love are taking place amidst the ashes of our fears. In time, despite the loss and grief, I pray that beauty will come out of this horrible situation.

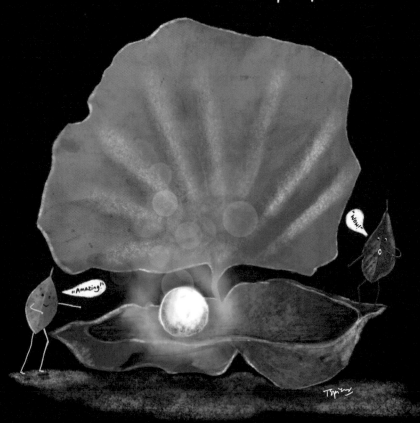

Day Thirty-two

"Pearl of great price." (NKJV)
Matthew 13: 45-46

I find it fascinating that a pearl is formed when something foreign - an irritant - slips into the oyster between the shell and mantle. The animal protects itself by depositing layer after layer of what is called *'nacre,'* around the irritant, which in time forms a pearl. A response to irritation creates something beautiful to wear.

This current situation is an irritant to our way of life and social interaction, but the way we respond to it makes a huge difference. We have a choice, daily, hourly, minute by minute as to how we get through this. Some days will be harder than others.

I pray we all respond well, protect ourselves and others and when we can open the shell and have a little bit more freedom, we will come out shining.

"You have collected all my tears in your bottle."
Psalm 56:8

TSpitz

Day Thirty-three

"You have collected all my tears
in your bottle." (NLT)
Psalm 56: 8

Our family started the year off in January mourning the
loss of my lovely mother-in-law. Many tears were shed in
the months leading to her death, due to the cruel disease of
Motor Neurone. Yet, despite the pain, there were
inevitably lovely funny moments too not only with her but
with her fantastic care workers.

Looking back we are so grateful she went home when she
did. We were spared the extra heartache of not being able to
be there. Many tears are being shed right now within
families who are robbed of their chance to be with their dear
ones in hospital, and my heart goes out to them. Scripture
says that the Lord stores up our tears, He sees them all and
understands. Whilst we are isolated physically in many
ways, we can be united in prayer for those who suffer. It
may be tears of mourning now, but there will be tears of joy
- we have to hold on to that.

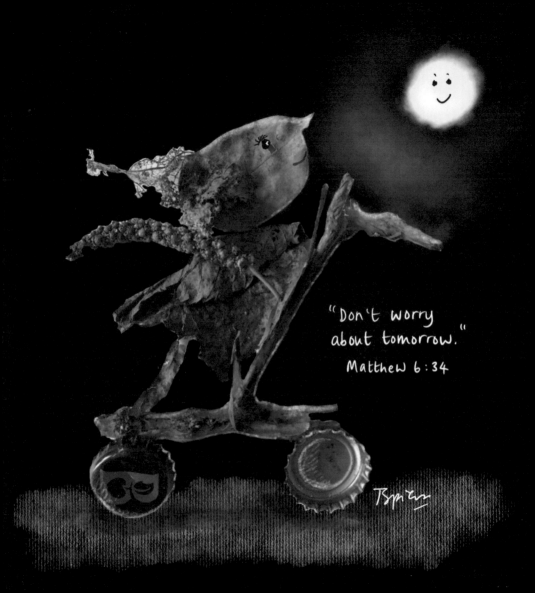

Day Thirty-four

"Don't worry about tomorrow." (NLT)
Matthew 6: 34

How easy it is to allow our thoughts to run away so that a small negative escalates into a mountain we can't climb. But this verse reminds us not to worry about tomorrow but to concentrate on the moment we are in.

Let's enjoy those precious moments - walking in creation, enjoying the warmth of the sun or breeze on our faces, talking to a friend on the phone, a hot bath, a bar of chocolate.

We need to relish the now and try not to let our thoughts steal it from us. Anxiety over tomorrow's concerns only robs us of the strength we need for today.

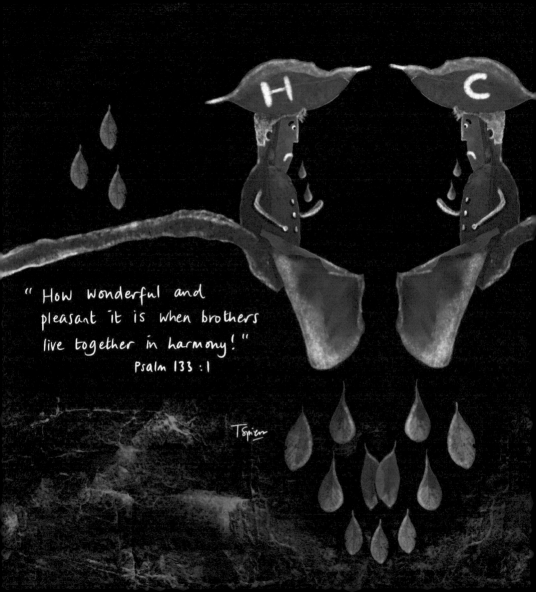

Day Thirty-five

"How wonderful and pleasant it is when brothers live together in harmony!" (NLT)
Psalm 133: 1

Over the years as we have brought up our five daughters, our house of seven has meant water bills are higher than many other households. Yet in recent months, every hot and cold tap has been turned on and off more than most, as we have constantly washed our hands.

This fun image showing two taps in debate, illustrates whilst a hot and cold tap are opposite in temperature they are equal in importance. As they both lament over the situation we are in, their hot and cold tears work together to find the temperature that is right for the user.

We may be opposite in temperament to our neighbours and friends, yet together, if we do the right thing, we can unite and fight for the good of all. We are also united in our tears.

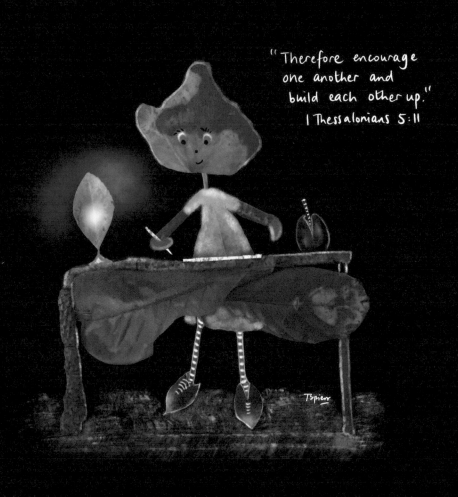

"Therefore encourage one another and build each other up."
1 Thessalonians 5:11

Day Thirty-six

"Therefore encourage one another and
build each other up."
1 Thessalonians 5: 11

How important words of encouragement are right now in this season where nothing is normal. It's as if we have been transported into a strange land which isn't very nice, apart from the comfort of nature and familiar sound of birdsong.

A phone call, letter, zoom session with friends, a WhatsApp video call with family are lifelines, helping us feel connected in our isolation. Let us rediscover what we did in the days before internet, computers and mobile phones - letter writing.

I hope my daily illustrations and thoughts encourage you. It is what I feel I can do right now. If we all encourage in our own unique way, I believe we end up encouraging ourselves too.

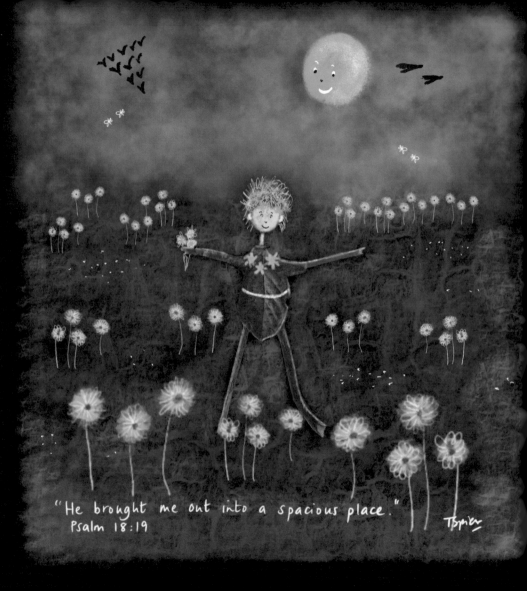

"He brought me out into a spacious place."
Psalm 18:19

Day Thirty-seven

"He brought me out into a spacious place."
Psalm 18: 19

I personally have always disliked being in confined spaces. I have avoided potholing and really struggle with crowds, partly because I am only five foot and find it hard being in a sea of chests. Whilst researching in preparation of writing and illustrating a history book for children in St Helens, Merseyside, I wanted to experience what it felt like to be in a coal mine so I went to the Big Pit in Blaenavon.

I did not like it, but wanted to appreciate the darkness and lack of space. It is similar to what we are all experiencing now - feeling trapped and restricted. Yet my daily walk or cycle rides are a tiny taste of that freedom we miss. A walk with my husband to a place known locally as *'The Heavens'* provides that open space we long for in our lives.

When I look up at the vast sky and experience the surrounding green, it is a reminder of what we will have again. This verse is a promise that we will be led into a spacious place once more.

Day Thirty-eight

"Create in me a clean heart." (NLT)
Psalm 51: 10

At the age of 10, I remember telling my Mum during one school holiday that I was bored, so she made me clean the windows. I never said it again! One of my daughters announced she was bored yesterday, so I challenged her and one of her siblings to clean the windows. I don't think they have been cleaned like that for years. The bees were so confused they got a headache!

Today's verse challenges us to clean our hearts. Windows look great only when both the outside *and* the inside are cleaned.

Personally I want to have a heart that is healthy in attitude, pumping with love, not bitter or jealous, but wanting the best for others and full of gratitude. My windows sparkle right now and are transparent. I want my heart to be the same.

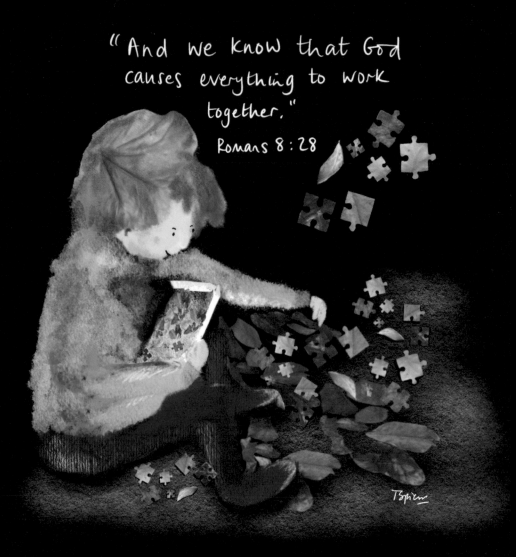

"And we know that God causes everything to work together."

Romans 8:28

Day Thirty-nine

"And we know that God causes
everything to work together." (NLT)
Romans 8: 28

I am sure my household is not the only one which has rediscovered a fascination for jigsaws. Every day the girls add another few pieces - a giraffe's neck, a flamingo's leg, an elephant's trunk to complete the Noah's Ark composition emerging on the jigsaw mat.

The current world situation is also a puzzle, yet we don't have a proper picture to help put the right piece in the right place. It is unknown.

COVID-19 is a Good Friday experience and just as the sky went black as Jesus died, the disciples must have felt in the dark and lost, as many of us do. But Easter Sunday was coming. As we look for the missing pieces in our jigsaw puzzles, there is a missing piece in this world puzzle - the hope that Easter Sunday is coming.

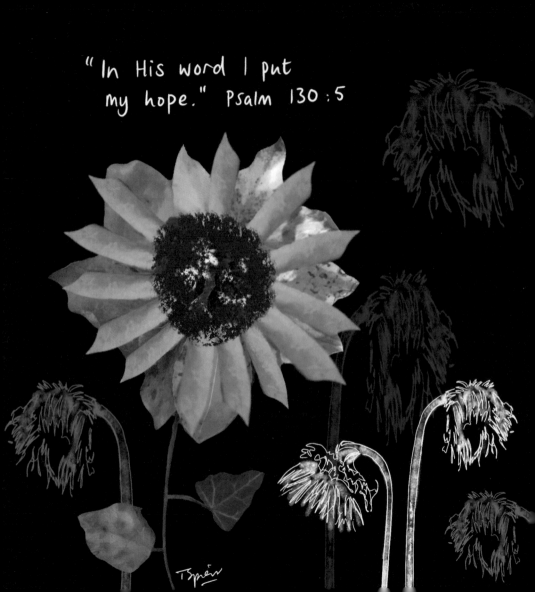

"In His word I put
my hope." Psalm 130:5

Day Forty

"In His word I put my hope."
Psalm 130: 5

I love sunflowers, there is something special about them as they turn their faces to the sun. Apparently a young sunflower faces east at dawn to greet the sun. As the sun moves across the sky, the sunflower slowly turns west and during the night slowly turns east again ready for dawn.

There's a degree of expectancy even in the dark. On Easter Saturday, the disciples must have felt despondent, heart-broken and feeling a loss of purpose and direction.

Many of us - including myself - have lost work and are not sure what our future employment will look like and we wait in silence. But like the sunflower I choose to turn my face towards the sun in faith and hope even though it is still dark.

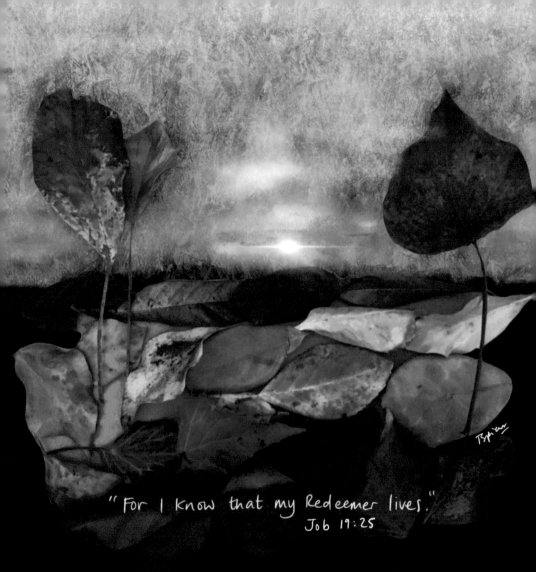

"For I know that my Redeemer lives."
Job 19:25

Day Forty-one

"For I know that my Redeemer lives."
Job 19: 25

I had intended to end my Lent Series today but due to circumstances, I feel it right to continue this until lockdown ends to provide a bit of encouragement and hope. In the Christian calendar, today has to be the most important day. It is the light at the end of a tunnel which starts with the despair of Good Friday, the confusion and sense of loss of Easter Saturday and concludes with the amazing reality of Easter Sunday, when the disciples discover the tomb is empty.

"He is not here for He is risen," an angel tells the two Marys. It is the fact that Jesus defeated death that gives us hope. It is a living and active hope, not a hope that wishes things were better, but a reassurance that no matter what situation we face, we have a hope in someone bigger than the circumstance. I don't know about you, but never before has the hope of Easter been more significant and important to me personally, than such a time as this.

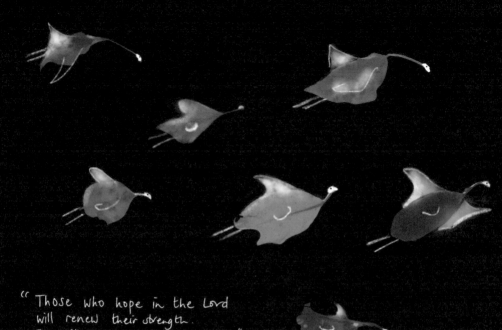

" Those who hope in the Lord
will renew their strength.
They will soar on wings like eagles..."

Isaiah 40:31

Day Forty-two

"Those who hope in the Lord will renew their strength.
They will soar on wings like eagles."
Isaiah 40: 31

Less traffic on the road has meant the sound of birdsong has dominated the airwaves and it is beautiful. I virtually met with five friends from Merseyside on-line yesterday morning and together we celebrated Easter Sunday at sunrise. We were joined by an uplifting morning chorus as two friends talked to us from their respective gardens.

Just as the birds sang with different tunes, each of us spoke in our own accents. We each are different in personality and each have a different song to sing. But we were all united in our love for the one who made us. As we move on from Easter, let us allow our spirits to rise like the birds flying around us. We may be physically restrained, but our spirits can soar as we add our song to their beautiful chorus. We can all sing about something we are thankful for despite the threatening clouds around us. Take courage.

Day Forty-three

"Let us not neglect our meeting together." (NLT)
Hebrews 10: 25

The concept of meeting together has a very different meaning for us right now. We played a game with my parents the other night. They sat at the table with us, but their faces appeared from a mobile phone. We have played Trivial Pursuit with several families, had virtual church services, whilst our children have had lectures, meetings, youth group and watched films together with friends using social media. An idea that would have seem alien when I was a teenager.

Yet a phone call is just as important - it is a life-line, connecting us to family, friends, neighbours and the community. Whilst we can not meet physically, social media enables us to still meet virtually. We are finding new creative ways of keeping in touch. We are designed to be connected - let's ensure we do our part in reaching out to those who find it hard. One phone call can make a huge difference. It shows we care.

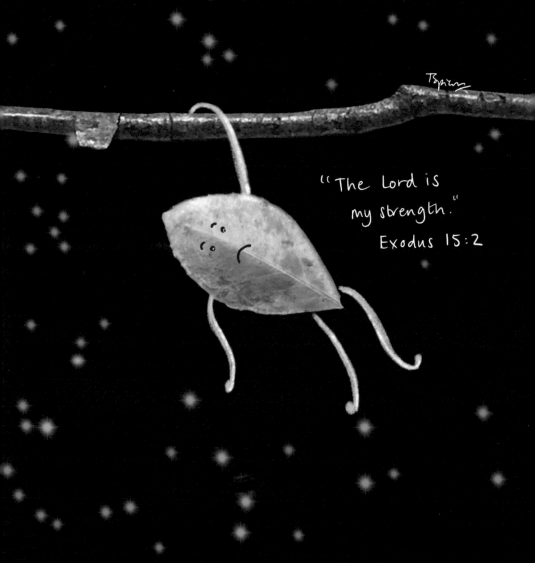

"The Lord is my strength."

Exodus 15:2

Day Forty-four

"The Lord is my strength."
Exodus 15:2

There are days when our doubts and negative whispers are louder than what we know in our hearts to be true. To be totally honest, I struggle at times to believe I will get work again in this uncertain season. Yesterday was one of those days, yet despite how I felt, I chose to hang on to the one I believe who holds me and my future, and believe He is still good. Just because we can't see any activity doesn't mean nothing is happening.

Allotments are getting dug ready for new seeds. A lot of growth happens in the dark before the shoots start to appear. Faith is about believing in what we can not yet see. Many of us have suddenly lost our work, but we can still have purpose. We only have to look at creation - it goes on creating. I encourage you be creative and try something new. But it is also ok to not be ok at times. Some days we may only have the strength to hang on with the tips of our fingers, but hang on we must. This too will pass.

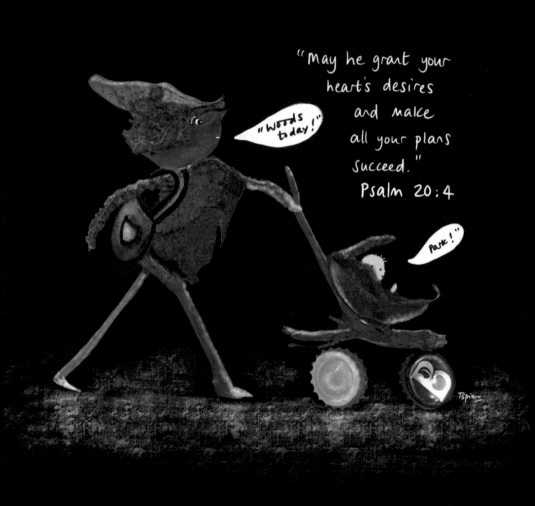

Day Forty-five

"May he grant your heart's desires and make all your plans succeed." (NLT)
Psalm 20: 4

Most of us like to plan. It gives us a little bit of security; we like to know what we are doing and where we are going. But I think it can also be driven by fear when we plan too much. In situations like this pandemic, suddenly all the appointments in our diary have been erased including holidays, day trips, conferences and exams. We can only live for today and some of us struggle with that. We want to know what's happening tomorrow. We are creatures of habit and children must wonder why they can't go and play at the park. Their heart's desire is to meet their friends, have picnics and be pushed on a swing.

Just because our dreams and desires aren't being realised right now, does not mean they won't. Maybe, just maybe we're being challenged to consider whether the motives and attitudes behind them are the right ones? Who knows we may come out of this season, with new dreams and desires that will bless many.

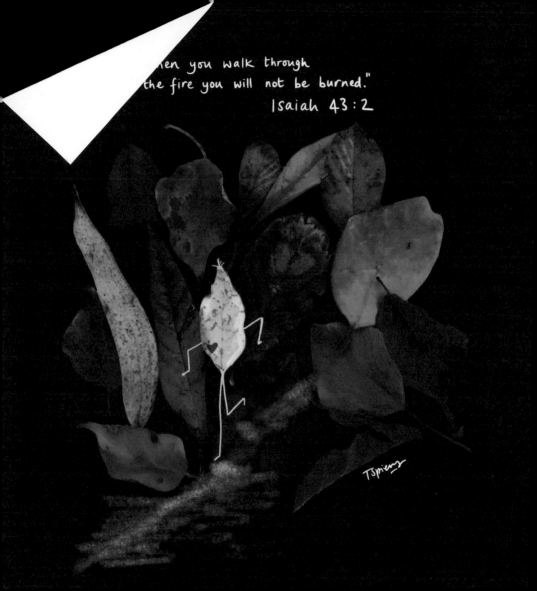

...en you walk through the fire you will not be burned."

Isaiah 43:2

Day Forty-six

"When you walk through the fire
you will not be burned."
Isaiah 43: 2

It certainly feels we are being put through a fiery furnace.
This season is a test of our strength, patience, courage, faith
and endurance. Yet this verse promises that we will come
out the other side. I hope we will come out refined and
changed for the better. The beauty and worth of a diamond
comes from the extreme pressure under which it is formed -
about 100 miles below the Earth's surface where it is at least
400 degrees C.

New wine is also produced after a lot of pressing and
crushing. I pray that we will come out of this process like
shining diamonds or excellent wine, where any dross is
removed in order for the good to shine and taste better.

But I also believe flames represent passion. I personally
want to be on fire for what matters.

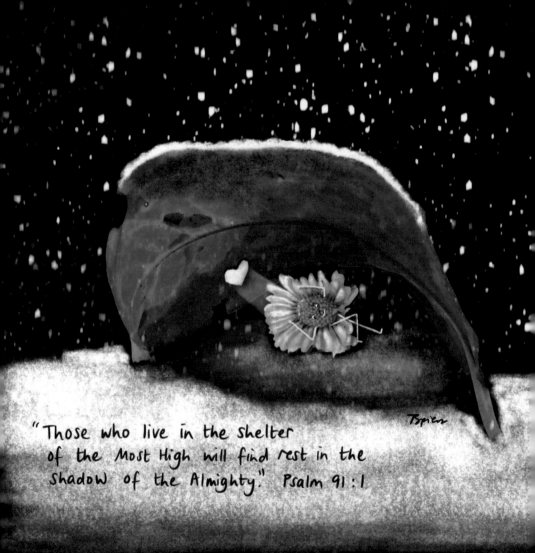

"Those who live in the shelter
of the Most High will find rest in the
shadow of the Almighty." Psalm 91:1

Day Forty-seven

"Those who live in the shelter of the Most High
will find rest in the shadow of the Almighty." (NLT)
Psalm 91: 1

Over the years as a runner, I have often got caught out by the weather and found myself miles from home without the appropriate gear to protect me from an unexpected downpour. I tend to just run through it knowing I can have a hot shower when I get home. Other times, I have sought shelter especially if I am in work mode and don't want to meet a client looking soggy.

The season we are in wasn't forecast and we are all in need of shelter - not only physically, but emotionally, mentally and spiritually.

We have a responsibility to protect our minds and hearts at this time as well as keeping safe for the good of others. Let us take shelter in the right places.

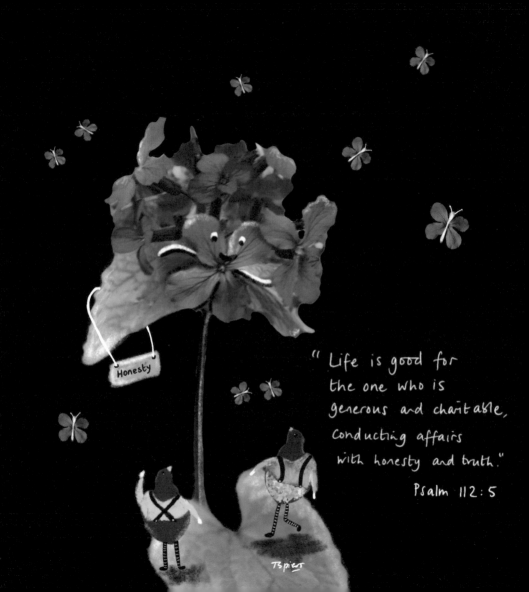

Honesty

" Life is good for
the one who is
generous and charitable,
conducting affairs
with honesty and truth."

Psalm 112:5

Day Forty-eight

"Life is good for the one who is generous
and charitable, conducting affairs
with honesty and truth." (TPT)
Psalm 112: 5

As I have been out and about on my daily walks, trekking through unfamiliar territory to avoid people, a gorgeous purple flower keeps catching my eye. Its name: honesty. Yesterday I took an early walk and saw a friend carrying a rather sad looking plant up the hill. She told me it had been neglected and she was taking it home to revive it. The plant was honesty. The former plant mentioned was thriving; the other was surviving but with her love and care I know it will look as it is meant to.

I shall remember this time as a season of honesty. Sometimes our *"I'm ok"* Britishness can stop us being real and vulnerable with each other. We are in this scary surreal season together, but the more we are honest and real with each other (and God), the closer we become, whether that is in families, neighbourhoods, church, communities or nations. Sharing what we have learnt and caring when each other hurts will help us thrive again.

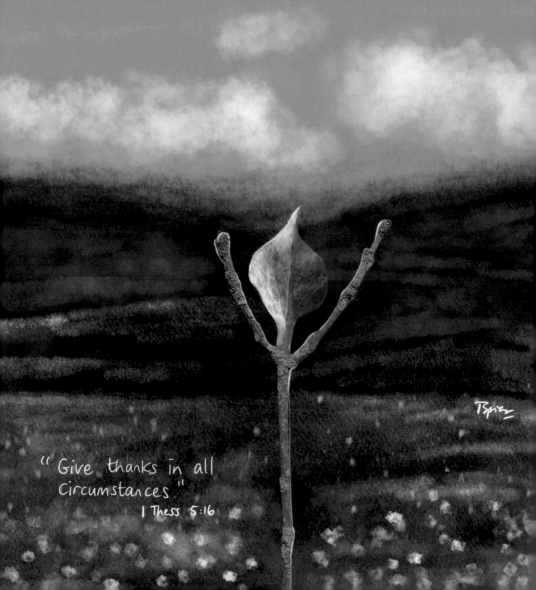

" Give thanks in all
Circumstances "
1 Thess 5:16

Day Forty-nine

"Give thanks in all circumstances."
1 Thessalonians 5: 16

Living in a town that is in the heart of five valleys, there are inevitably steep hills to climb up and walk down. My best walks are when I have reached the highest point and can overlook the valleys below. Everything looks perfect there and on a clear day, one can see for miles. It literally does feel like being on top of the world.

I have grown up with these hills and valleys, and yet of late, I have again fallen in love with these wonderful, inspiring surroundings.

What a privilege to enjoy this amazing artistry. It lifts my spirits and I can't help being thankful and my heart is full of praise. It strengthens me and enables me to walk back down to the valley below.

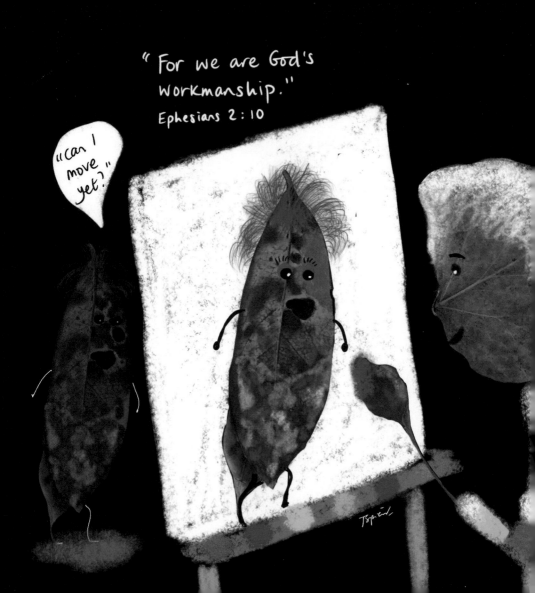

Day Fifty

"For we are God's workmanship." (NLT)
Ephesians 2: 10

My youngest two daughters are non-identical twins, totally different in looks and personality, yet equally as precious. A couple of years ago, they joined their older three siblings in a local production of *The King & I*. Cast as twins, they were dressed in identical costumes with their hair in buns. They suddenly looked the same and could easily have passed as identical twins. Whether we have family resemblances or not, we are all unique and designed that way for a purpose.

I like to think that we are works in progress, being moulded and shaped by our Creator as we go through the rollercoaster of life. We are always quick to see our own faults and want to correct the image in the mirror, but let's take comfort in this fact - there is no one else like you or me.

Quirky as we might be, let us be our best selves and use who we are and what we have to encourage others, knowing He hasn't finished with us yet.

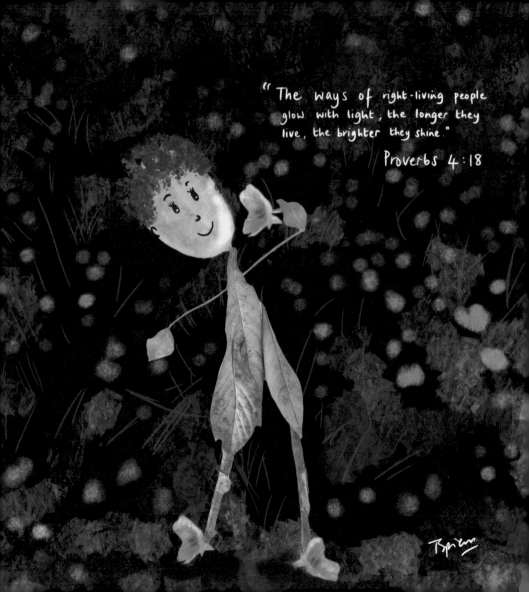

"The ways of right-living people glow with light, the longer they live, the brighter they shine."

Proverbs 4:18

Day Fifty-one

"The ways of right-living people glow with light,
the longer they live, the brighter they shine." (MSG)
Proverbs 4: 18

As a child, I used to hold a buttercup under my chin to see if I liked butter. Of course my chin always radiated a yellow glow whether I liked butter or not. The reason buttercups shine with an intense glittering yellow is to attract insect pollinators. They have a glossy glowing surface due to layers of air just beneath the surface which reflect light like mirrors. But they also need the sun to be high in the sky. They carefully track it. On cold days their petals become cup-shaped to collect solar energy; on warm days they focus the sunlight into its centre boosting the ripening of pollen. When Moses came down from Mount Sinai, having spent time talking with God, he didn't realise that his face was shining. I personally do not agree with the lyrics of a well-known song, that *God is watching us from a distance*. I believe He cares about every detail of our lives and wants us to talk to Him - which is what prayer is. He is love and every time we see love in action we see Him at work. The more we grasp and track that love - like the humble buttercup - the more we radiate it.

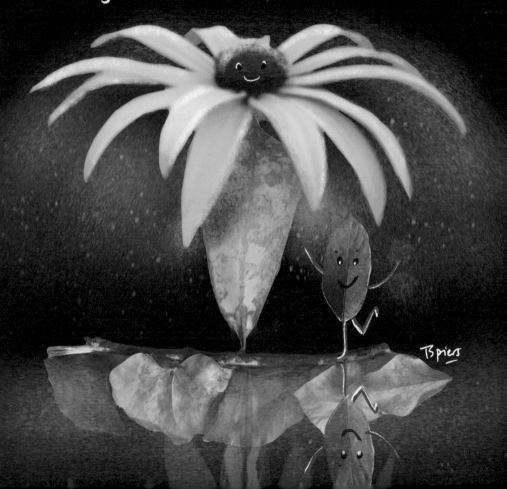

"Be cheerful with joyous celebration in every season of life." Phil 4:4

Day Fifty-two

"Be cheerful with joyous celebration in
every season of life." (TPT)
Philippians 4: 4

Years ago when our middle daughter was a toddler, we were
camping in The Vendée. Being in an unfamiliar place, she
didn't sleep, so to prevent waking the whole campsite, my
husband and I took turns to push the pushchair around the
site. Early one morning, as she finally dozed off, I perched
on a wall for a rest. Within seconds I physically leapt in the
air. I had been sitting on a water fountain, which was on a
timer and had come to life at that exact moment.

There is something joyful about water fountains. Children
enjoy running through them on a hot day, squealing as the
spray hits their bodies. One fountain I love is in Taylor Park
in St Helens, Merseyside. It looks like a giant dove taking off
out of the water. Fountains represent life, a symbol of
eternity. We may be physically restricted, but we can still
let the well-spring of our inmost being rise. And let us not
forget to laugh, it is such good natural medicine.

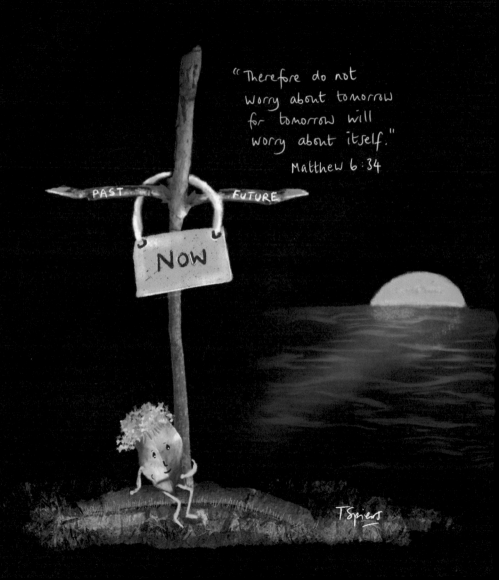

Day Fifty-three

"Therefore do not worry about tomorrow for
tomorrow will worry about itself."
Matthews 6: 34

I have always been ahead of myself. I was born
prematurely and as a child would constantly ask, *'what are
we doing tomorrow?'* when we hadn't even got past
breakfast. I finally learnt to live one day at a time when I
gave birth to twins, 13 years ago. I suddenly had five
children under the age of 7 and literally lived one minute at
a time in order to cope with the logistics of getting them all
fed, dressed and out of the house by 8.30am.

However at times I still find my mind races ahead of me; the
'what ifs' rob me of today's blessings and I realise I haven't
appreciated what is around me. Yesterday has gone and
tomorrow is unknown. But we have today. I know God is
faithful and He holds tomorrow. In the wilderness, the
Israelites were given manna from heaven - enough
sustenance for that day. We too are given grace for today.
Let's enjoy the now and be thankful for the little unexpected
joys we so often miss when we think too far ahead.

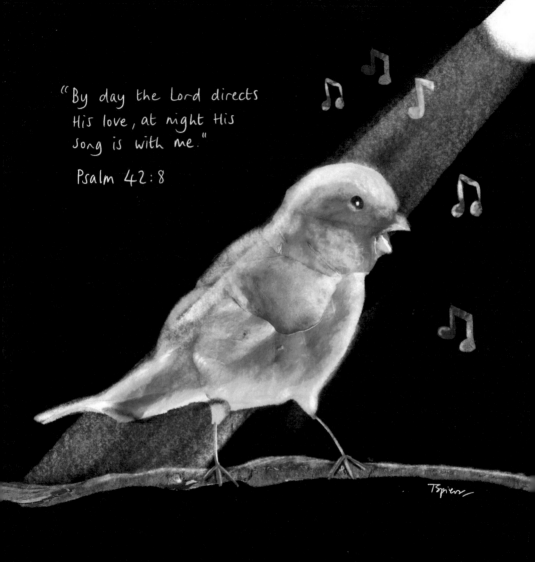

Day Fifty-four

"By day the Lord directs His love, at night
His song is with me."
Psalm 42: 8

I have had the privilege of writing and illustrating a
history book which pays tribute to this beautiful singing
bird. Miners would take canaries with them into the pits as
they could detect dangerous gases. If the birds got agitated,
the men knew they had to get out of the mine quickly.
Many got attached to these cheerful birds and enjoyed their
company. In time special resuscitation cages were designed
so that if the birds got poorly due to the gases, the miner
could release oxygen to revive them. Daytime was night in
the pits so the birds chirped away in darkness, unless
something dangerous was in the air.

It may be a dark season, but our songs are important.
Singing lifts our spirits out of the shadows and restores our
joy. When the canary sang, the miners knew all was well.
Perhaps we too can sing in faith that all will be well.

"He determines the number of the stars and calls them each by name." Psalm 147:4

Day Fifty-five

For the past few nights our youngest daughter has been desperate to watch the train of Elon Musk's Starlink satellites as they pass overhead. It has meant patiently gazing up at the night's sky. Kezia chose to lie on the grass to wait in hope. Whilst she was rewarded with some activity, it wasn't nearly as impressive as the stars themselves which appeared to sing in their mesmerising way.

Almost 30 years ago, I spent many months in Fiji and took comfort in staring at the night's sky, knowing my family was enjoying the sun's rays on the other side of the world. This verse says that God knows each of the stars by name. I also believe He knows each of us by name and loves each and everyone of us.

We may seem small and insignificant as we look up at the amazing galaxies, but we are precious in His sight. If only we could grasp that.

"The one who sows from a generous spirit will reap an abundant harvest."

2 Corinthians 9:6

Day Fifty-six

"The one who sows from a generous spirit will reap an abundant harvest." (TPT)
2 Corinthians 9: 6

My husband and I took an early morning walk yesterday to try and see if we could spot a kingfisher. As we stopped to watch and wait at a beautiful habitat, we prayed together. A slight breeze caught hundreds of dandelion seeds which took off in magical fashion. They were ready to fly and go where the wind took them. They will drop to the ground and come up again multiplied. The name dandelion means *'teeth of the lion.'* It may be considered just a weed by many, but it has an unseen power and strength to rise up and shine despite being mowed down. The mature dandelion in its clock-form, is ready to go. However you see the seeds - whether it is us, our gifts, our prayers - let's be ready to use what we have when the time is right.

I have no idea where my words and pictures go as I put them up on social media, but I am throwing them out, praying they reach the right people at the right time to bless them.

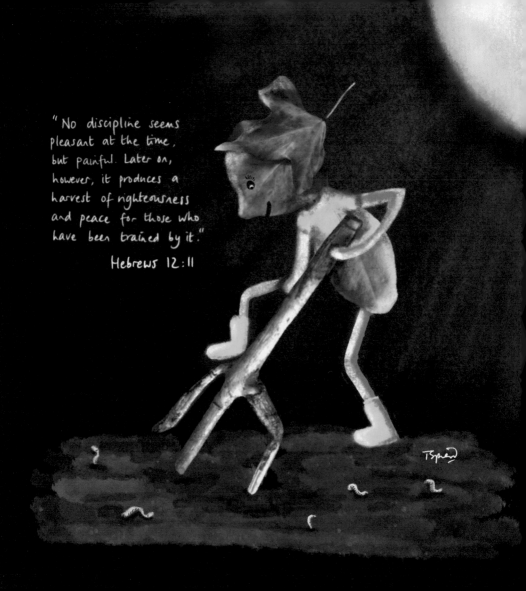

"No discipline seems pleasant at the time, but painful. Later on, however, it produces a harvest of righteousness and peace for those who have been trained by it."

Hebrews 12:11

Day Fifty-seven

"No discipline seems pleasant at the time, but painful.
Later on, however, it produces a harvest of
righteousness and peace for those
who have been trained by it."
Hebrews 12: 11

Like many allotment-holders, my husband has been digging up the soil ready for planting. It's been hard work due to a lack of rain. With its piercing tines, a garden fork can penetrate the ground much better than a spade. It helps pull out stubborn roots, aerates and sifts the soil. It does feel like the coronavirus has been a three-pronged attack on our financial security, health and personal freedom.

Familiar soil has suddenly shifted and turned upside down. But when any soil is tilled, large stones come to the surface to make way for new crops to grow. This season can be unsettling, bringing our insecurities and fears to the surface, but it can also bring to mind the simple things forgotten from our childhood - like baking, creating, mending, sorting through photos, den building, bug watching, book reading, praying and playing games. In the pressing and shifting, let us make room for new ways of being, doing and thinking.

"The eternal God is your refuge, and underneath are the everlasting arms."

Deuteronomy 33:27

Day Fifty-eight

"The eternal God is your refuge, and underneath
are the everlasting arms."
Deuteronomy 33: 27

Today's thought comes with a degree of heaviness and the
reality that love hurts. When we care about friends who
have lost dear ones, we feel that loss with them and our
hearts go out to them. Coronavirus has cruelly taken lives
and whilst many of us are cocooned, it is mercilessly
attacking those around us. There's a deeper unity happening
as a result. We all know the pain of bereavement but social
distancing makes it even harder to offer that physical touch
so needed at this time.

My prayer is for those experiencing that heartache right
now, that they would know a tangible presence of God's love
who isn't social distancing. Never before have we needed
Him more. Let us, despite the physical barriers, show that
love to those who really need our support right now.

Death may appear to have won, but love ultimately wins and
can never be destroyed.

"Let the wise listen and add to their learning." Proverbs 1:5

Day Fifty-nine

"Let the wise listen and add to their learning."
Proverbs 1: 5

For many years I worked for the BBC in local radio as a broadcast journalist. Very often I would wake up to hear the sound of my own pre-recorded voice coming out of the radio. My aim was always to make my stories interesting and engaging enough so that people didn't turn the radio off. It meant being creative with sound effects to help the listener understand where and what I was doing.

Finding the right frequency is always a challenge in an area full of hills and valleys. The radio station is often lost driving through the valleys but much clearer on a hill.

On a daily basis, so many noises can grab our attention but they are not always helpful or encouraging. Our own thoughts can be just as negative as the news. It is important to know how to tune out of the things that drag us down, as well as knowing how to tune into the right voices that build us up. It is only when we allow our hearts and minds to be still that we hear that small voice of calm, whispering *"I am with you."*

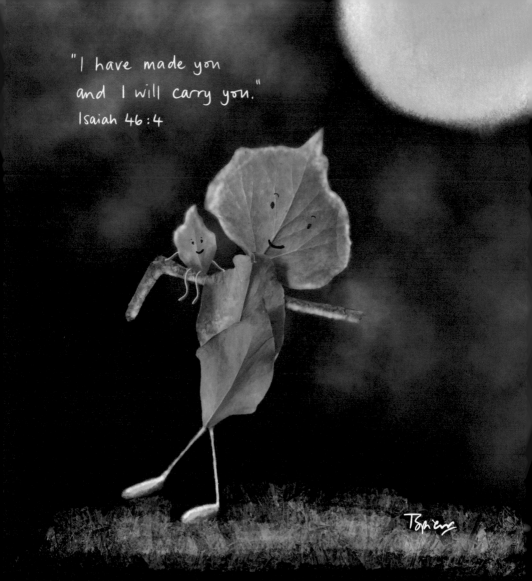

"I have made you and I will carry you."
Isaiah 46:4

Day Sixty

"I have made you and I will carry you."
Isaiah 46: 4

Being vertically challenged, I struggle in crowds and avoid
concerts as all I see is a sea of chests. Ironically it is not
something I need to worry about at present. However I
do sometimes wish I had a few extra inches. When I was
a child, my dad would often carry me on his shoulders if I
got tired. We did this for our own children. I am sure they
feigned tiredness just to be lifted up. As adults we still need
that lift when life is overwhelming and we are exhausted.
The words I want to say are eloquently put in the lyrics of
this song by King & Country.
"My help comes from You
You're right here, pulling me through
You carry my weakness, my sickness,
My brokenness all on Your shoulders;
My help comes from You
You are my rest, my rescue
I don't have to see to believe that
You're lifting me up on Your shoulders."
If you are weary today, let your loving Heavenly Father
lift you. It won't take the situation away, but you'll get the
strength to cope.

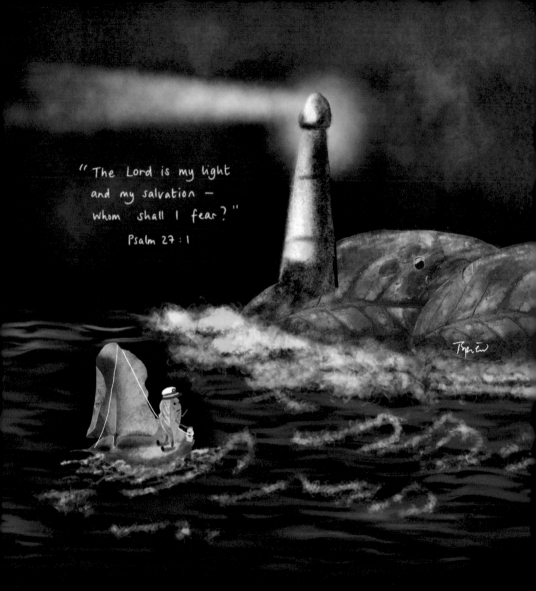

" The Lord is my light
and my salvation —
whom shall I fear? "

Psalm 27 : 1

Day Sixty-one

"The Lord is my light and my salvation
- whom shall I fear?"
Psalm 27: 1

We all need a guiding hand sometimes to lead us back to safe harbours, especially if the water we are in is choppy, we can't swim and the boat is being buffeted. Lighthouses are strong towers, they act as a refuge and a warning for those at sea who are vulnerable. But they too are vulnerable because in order to fulfil the job they do, they are set aside, often high up and isolated from other buildings. They feel the waves, the erosion and storms. Yet their light can not be put out and they help many to safety.

Whether you currently find yourself a lighthouse to others or are the one in the sea needing a friend, I pray for strength, courage and hope. What we go through is never wasted and whilst you might be in a storm today, you will in time be the one acting as a lighthouse to help others who will go through the same storm you are currently experiencing. Take courage, the storm will pass.

"But the greatest of these is love."
1 Corinthians 13:13

Day Sixty-two

"But the greatest of these is love."
1 Corinthians 13: 13

One thing my husband and I are not good at is dancing. We took a few lessons so we could at least lead the first dance at our wedding. That was 23 years ago today. Whilst dancing is not our gifting, we do work well together and have learnt to play to each other's strengths. He wants the best for me, I want the best for him and the greatest gift we have given our fantastic five daughters is to love each other. Naomi, our eldest, was born exactly 20 years ago on our third wedding anniversary. I remember whispering to Rog: *"You'll be able to walk her down the aisle one day."*

Little did we realise four more girls would follow! Our love for each other is strengthened by our faith in God who is Love Himself. We love because He first loved us.

Today, I want to honour this man I am proud to call my husband and the father of my children. His love illustrates patience, kindness, respect, honesty and never gives up. It mirrors God's love and I am truly grateful.

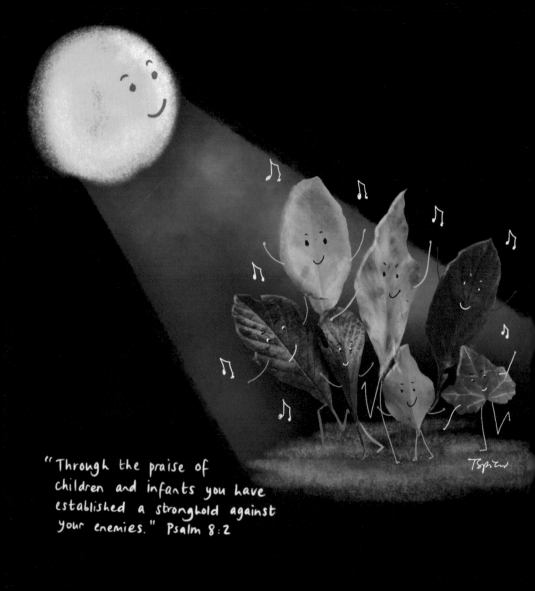

"Through the praise of children and infants you have established a stronghold against your enemies." Psalm 8:2

Day Sixty-three

"Through the praise of children and infants you have established a stronghold against your enemies."
Psalm 8: 2

There is nothing more uplifting than the sound of children singing. I join the parents, grandparents, aunts, uncles, teachers and classroom assistants who have enjoyed watching little ones singing *Away in a Manger* at Christmas or *Cauliflowers Fluffy* at Harvest Festival. It either produces the following: a smile, a tear, an ahhhh.

Living in a houseful of girls who all love musical theatre, I am blessed to hear my daughters erupt into spontaneous song at any time. I live in a happy house most of the time and it does give me strength when I hear this as opposed to arguments, which can also happen. Children are a real tonic and we miss seeing them playing and singing together in their school settings. The atmosphere changes when they sing.

When we hear that sound again, we know that our nation is on the mend. In the meantime join your children in cheerful song where you are - it is powerful.

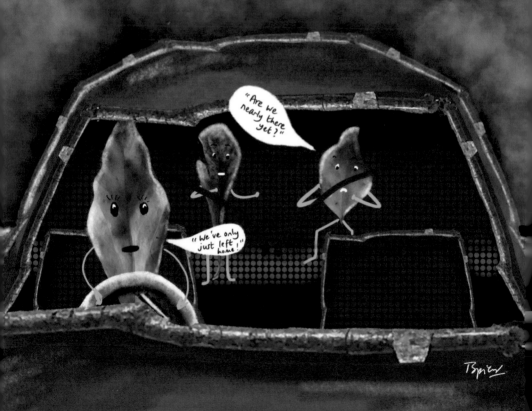

Day Sixty-four

"But if we hope for what we do not yet have,
we wait for it patiently."
Romans 8: 25

There is one question most of us have asked our parents during our lifetime when embarking on a long journey and that is, *'are we nearly there yet?'* Inevitably when children are small, the question usually comes just minutes after leaving the house when there is about 150 miles to go. The journey we are currently on in lockdown feels a long one, and we are like children in the backseat, asking *'are we nearly there yet?'* Only the driver knows where we are going and the estimated time of arrival.

There is a big unknown as to where we are heading and what indeed the landscape will look like when we do arrive. Perhaps instead, the question to ask is this, *who* are we trusting to get us there safely? I personally would rather wait until it's the right time before getting out of the car. Waiting is hard sometimes, but wait we must and with patience.

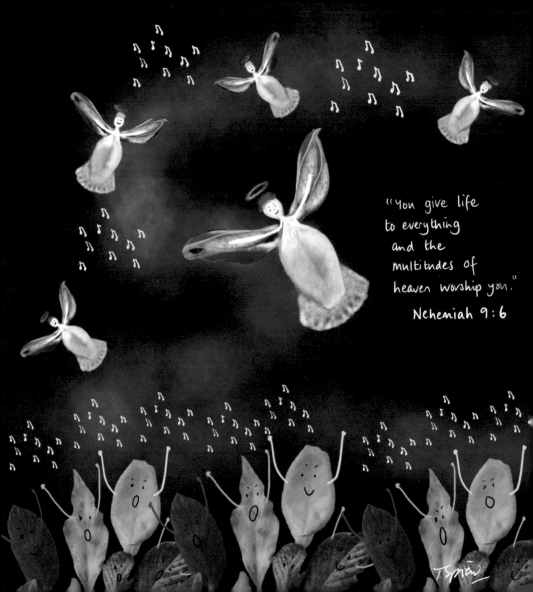

"You give life
to everything
and the
multitudes of
heaven worship you."

Nehemiah 9:6

Day Sixty-five

"You give life to everything and the multitudes of heaven worship you."
Nehemiah 9: 6

The words praise and worship appear hundreds of times in the Bible and are key in many dangerous situations. In the natural, it must have seemed a strange battle plan to sing whilst the enemy invaded, but Jehoshaphat's army sang, praised and won. In Psalm 22:3 it says that the Lord actually lives and dwells in our praises. When we worship, we affirm the truth of God's word even if we may not feel it.

We all worship whether we realise it or not. Football fans worship when they watch their team play, music lovers worship at concerts when their favourite bands perform. For that moment, people are united. Similarly when we worship God, we sing a universal language and it unites hearts globally. It's a declaration of our weakness and God's strength. I believe when we worship, the invisible God is at work doing amazingly powerful things. There's a line in one of my favourite contemporary worship songs that says: *"when we hear praises, He hears faith."*
That so inspires me.

"He brought me
out into a spacious
place." Psalm 18:19

Day Sixty-six

"He brought me out into a spacious place."
Psalms 18: 19

This image epitomises freedom - being free of restraints, free of worry and free of pain. I am blessed by the countryside I live in. Being based at the top of a steep hill not only keeps me fit, but enables me to see for miles across the valleys below and the silvery River Severn in the distance. It provides space to think, to meditate, to pray, to be thankful. In these times of restraint, being able to walk into a spacious place is a gift. But I am conscious not all are able to do this right now. Yet it is a promise for what is to come.

It also challenges us to think about areas in our lives where we have put limits on ourselves or allowed others to put restrictions on us, by what they have said or not said.

There may be a dream you have that has not yet been fulfilled and when restrictions are lifted, it could well be the very thing you need to pursue. Whatever *spacious place* means to you, I pray you will see it come to pass very soon.

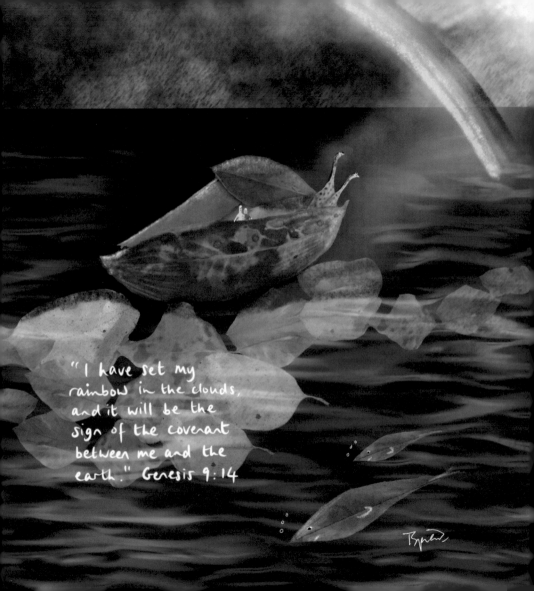

"I have set my rainbow in the clouds, and it will be the sign of the covenant between me and the earth." Genesis 9:14

Day Sixty-seven

"I have placed my rainbow in the clouds. It is the sign of my covenant with you and with all the earth." (NLT)
Genesis 9: 14

We may be in lockdown, but at least we are not stuck inside with every creature on the earth. I don't have to stop my daughters eating each other! Noah was in lockdown for about a year in all and his hair must have been exceptionally long by the end of it. One sign we will remember this historic season of lockdown by is the rainbow. The NHS has been our hope in what has been a scary time.

But it is not *the* hope. The rainbow was a promise to Noah from God that never again would He flood the whole earth. The Bible is full of promises - some 3,573 in all. And they are still trustworthy and reliable in our modern world. He promises He will never leave us or forsake us and whilst it might seem as if He is silent, it doesn't mean He is not at work.

He will turn this situation round for our good and His glory. We just need to hang in there - and not worry about our ever-growing hair!

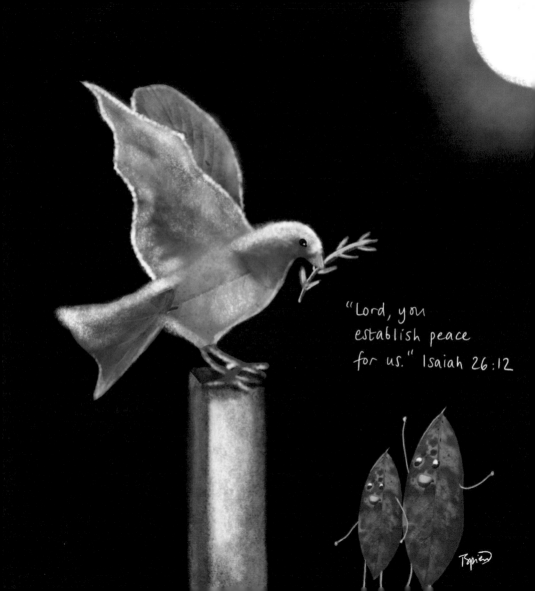

"Lord, you establish peace for us." Isaiah 26:12

Day Sixty-eight

"Lord, you establish peace for us."
Isaiah 26: 12

Continuing with the theme of the ark, Noah didn't have Facebook, Instagram or Twitter, but he did have a dove which he sent from the ark to establish whether flood waters had subsided. He sent it out three times. The first time the bird returned with nothing. A week later, it returned with an olive branch in its mouth - the sign that the world was starting to get back to normal but wasn't quite there yet. Another week later, Noah sent the dove a third time and this time it didn't come back as it had found a new home on land.

The olive leaf was a sign of hope. It gave Noah a sense of peace and reassurance that all would be ok and his time on the ark would end. New life came after the flood. And it will for us after Coronavirus. Whether you see the dove representing the Holy Spirit, a symbol of peace to soothe and quieten our troubled thoughts, or an emblem of purity and harmlessness (or all three), let's take its olive branch and know land is near.

"So I recommend having fun"...

Ecclesiastes 8:15

Day Sixty-nine

"So I recommend having fun..." (NLT)
Ecclesiastes 8: 15

I have always been inquisitive, asking the *'whys'* and the *'what ifs'* - not in a negative way but because I just wanted to know the answers. I got a small dice stuck up my nose when I was 8 just because I asked myself, *'what would happen if I sniffed it?'* The inevitable happened and I ended up in A&E! Roll on 40 years and I haven't changed much in my approach to life. I still have that sense of adventure and don't mind exploring unknown territory. As a result I am physically walking many new paths totally unconcerned that I may get lost.

There's freedom in the not knowing because there are surprises along the way. So today's message is this, do something that makes you laugh and lifts your spirit. My life's motto is *'grow young'* and that means seeing the world with child-like wonder. It's amazing what a feather, piece of bark, a bottle top and a large leaf can turn into with a bit of imagination. I am not really sure what this creature is, but it's expressive fun.

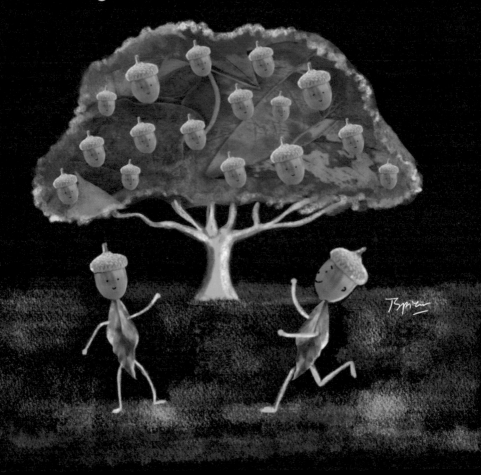

Day Seventy

"They will be called oaks of righteousness."
Isaiah 61: 3

Apparently it takes an oak tree 300 years to grow, 300 years to live and 300 years to die. That's pretty impressive. When the seedling pushes through the ground it is already 100% oak tree even though it doesn't look like one yet. It is interesting that this verse refers to oaks as opposed to oak, singular. Woodland oaks grow together, they are much straighter and higher than field oaks, as they reach towards the light.

Being with others straightens us out and encourages us to reach higher in our faith. This verse is about spiritual growth and maturity. When we come to faith, we have a new identity in Christ and live as we were always made to be, free from what others expect. Just as the seedling, we are destined to reach our full potential, even though we may still feel like a seedling.

As Mufasa says to Simba, his son: *"Remember who you are."* Or perhaps it should also read: *"Remember whose you are."*

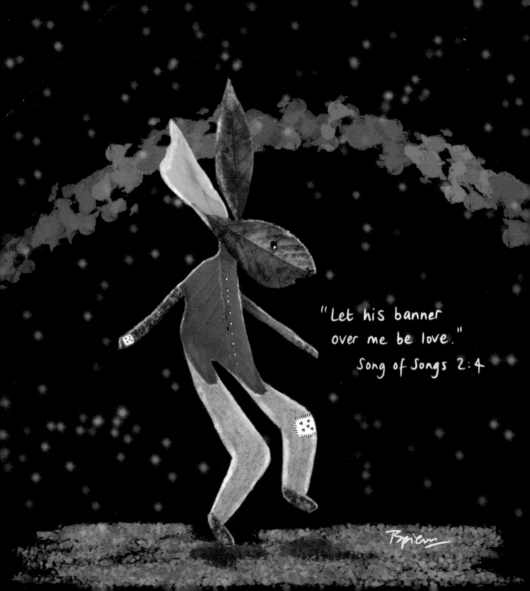

"Let his banner
over me be love."
Song of Songs 2:4

Day Seventy-one

"Let his banner over me be love."
Song of Songs 2: 4

We have an extra member in our family. His name is Rabbie. He is a well-loved toy rabbit that is thirteen this week. He has been so loved by his owner, Rosie that I have spent many an hour sewing patches on his threadbare limbs and delicately mending him over the years. When Rosie was five, Rabbie made newspaper headlines because he got left behind at the local Wildfowl and Wetlands Trust. It took 10 days (and upsetting nights) before he was finally found outside the flamingo pen.

There was great rejoicing - although it took two washes and more emergency repairs before Rosie believed it was her beloved rabbit. Her story is similar to *The Velveteen Rabbit* whereby a toy rabbit becomes real because it is loved enough.

We too become real and free to be the person we were meant to be when we are loved enough.

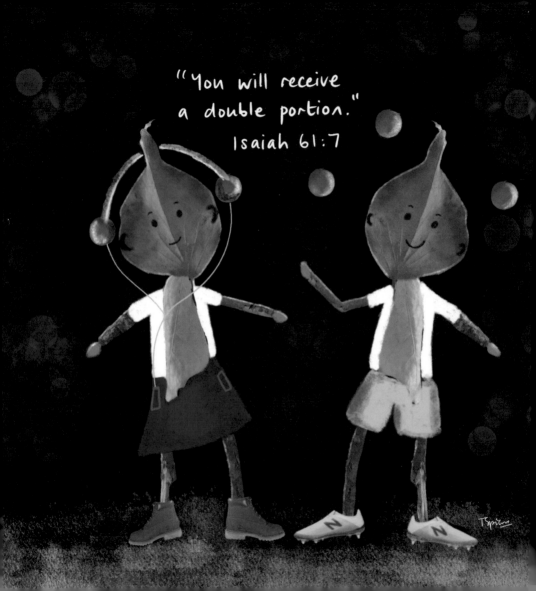

Day Seventy-two

"You will receive a double portion."
Isaiah 61: 7

I was told not to have any more children after my third daughter arrived. She was born seven weeks early and my womb couldn't hold her. Just over two years later I found out I was pregnant again and I can't deny it, I was fearful. A few weeks on, a vivid double rainbow made me stop in my tracks and I took a photograph. As I did so, a thought popped into my head that I was about to receive a double blessing.

The next morning, my scan revealed not one baby, but two. I went white as a sheet. How would I carry one, let alone two babies? Yet I recalled the double rainbow, and I had the courage to believe that I would be able to do it. They were born full-term and delivered without pain relief. My double blessing - Rosie and Kezia - are teenagers today. Uniquely different, equally precious.

There are many references to double portions in the Bible and I believe the Lord wants to bless us so richly. Sometimes we just need to learn how to receive.

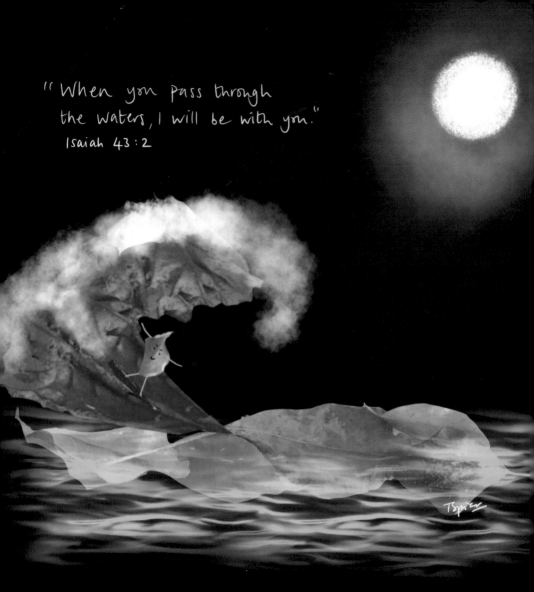

"When you pass through the waters, I will be with you."
Isaiah 43:2

Day Seventy-three

"When you pass through the waters, I will be with you."
Isaiah 43: 2

The sea fascinates me. I love skimming stones on the surface, watching my husband try and jump the white horses as they crash against the shore and admiring surfers who can effortlessly ride the waves. Yet I also have a healthy fear of the sea. One day it can be still, another it can be wild and unpredictable.

I guess life is like that. We expect one thing, and sometimes get another. But I take comfort in the fact that the one who created the sea, can also calm it. I don't believe that the Coronavirus was God's plan for us, but He can help us ride the unpredictable wave with the skill and grace of a practiced surfer.

I guess the surf board we stand on is called trust.

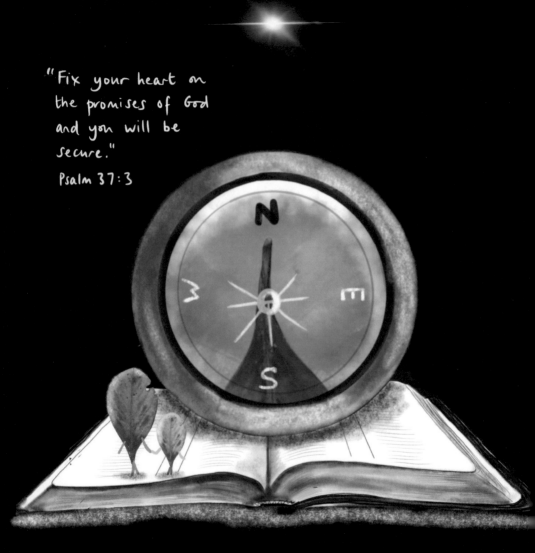

"Fix your heart on the promises of God and you will be secure."

Psalm 37:3

Day Seventy-four

"Fix your heart on the promises of God
and you will be secure." (TPT)
Psalm 37: 3

I have never had a good sense of direction. I was born the wrong way round and still have to think about my lefts and rights. However I am not afraid to ask for directions and often stop to ask someone when I am not sure if I am on the right road. All navigators and true explorers are aware of the importance of following *"true north."*

Magnetic compasses point towards *'magnetic'* north. This isn't the same as true north, which can be several hundred miles apart. True north is a fixed spot on the globe, at the conjunction of the lines of longitude. Magnetic north varies position from year to year.

In the Christian faith, Jesus is the true north and is described as the constant, the same yesterday, today and forever. (Hebrews 13:8). If we set our moral standards in line with His then we are less likely to get swayed by other influences. At such a time as this, let us keep our inner compass pointing in the right direction. We are less likely to feel lost.

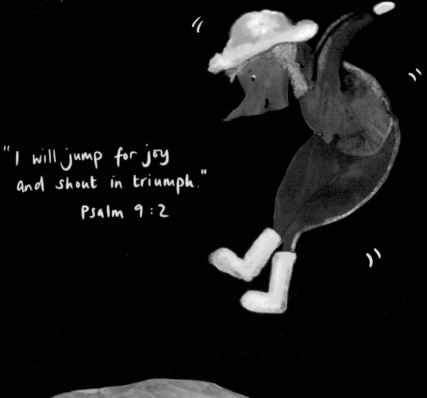

"I will jump for joy
and shout in triumph."

Psalm 9:2

Day Seventy-five

"I will jump for joy and shout in triumph." (TPT)
Psalm 9: 2

I like thinking outside of the box and doing life differently. I however do not like being restricted, so the inner child in me today wants to do something child-like such as jumping in a large puddle without worrying about mud splashing everywhere. Having a houseful of young people keeps me young. When the girls were small, I used to take them on a trip around the world on a magic carpet. In the current climate I am tempted to do that now! We would sit on the carpet and then stop at a country and imagine what it would look like, feel like, what foods we would eat and the colours we would see.

If the children had a tantrum in the car, I would pretend to have one too. So shocked by my outburst, they would immediately stop theirs and peace would return.

We can be so serious at times and that is right and proper, but it is also important for our mental well-being that we let our hair down - and there is a lot more than usual - and do something that re-kindles the child within.

" I will give you rest."

Matthew 11:28

Day Seventy-six

"I will give you rest."
Matthew 11: 28

As my family and friends know I am not very good at sitting still. I am a Tigger by nature and the only things that seem to make me stop are sunbathing, savouring a good coffee or reading an engaging book. Even if I sit in front of the television - which is a very rare event - I have to be doing something. So the word *rest* does not come naturally to me. Before lockdown I was in a season of enforced rest. I had a fractured heel and had no choice but to rest my foot.

Now I have most of my mobility back, I want to get out and be active. Rest is important. It allows our mind, body and soul to be renewed. I hadn't considered this before but rest is part of the word restored. We need it, the world needs it. If God needed to rest on the seventh day after creating all that He did, then surely so should we? So I am telling myself this today - slow down, rest and sit still - even if it is for a few minutes. Or as one friend used to say to me: *"Settle Petal."*

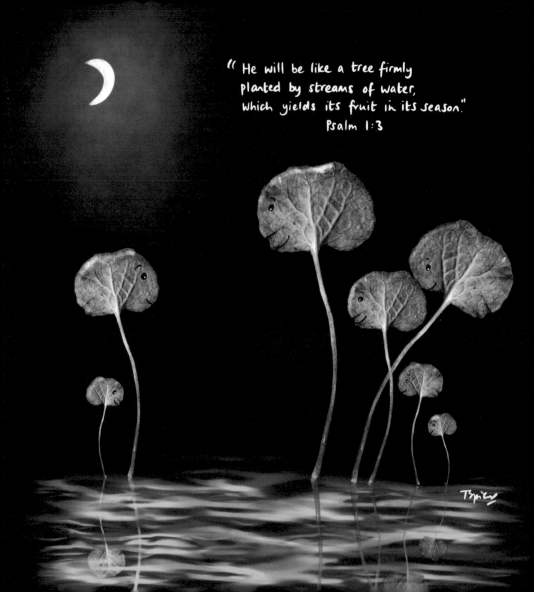

" He will be like a tree firmly
planted by streams of water,
which yields its fruit in its season."
Psalm 1:3

Day Seventy-seven

"He will be like a tree firmly planted by streams of water, which yields its fruit in its season." (AMP)
Psalm 1: 3

On one of my many walks of late, I came across a large tree which had been completely uprooted. No longer in the ground, its roots were now exposed for all to see. They were huge. It led me to find out more about tree roots.

Take a 60ft tall maple for example, its roots extend 100ft down into the ground. This verse talks about us being like trees. We have a choice where to plant our roots and how deep they are - they can be shallow or they can be deep. Those who choose to put their roots into life-giving water, who faithfully do good and don't give up, are reassured that they will see fruit and at the right time.

One character in the Bible who was faithful despite his circumstances was Joseph and at the right time, he saw the fruit of that faithfulness. I personally want to be someone who is constantly digging deep, steadfast in doing good and trusting that at the right time, I too will produce fruit that will edify and build others up.

Day Seventy-eight

"Love covers over all wrongs."
Proverbs 10: 12

In the early years of my journalism career, the newsroom sounded like a firing squad with reporters bashing away on their cumbersome typewriters. When I left my local paper, I received a thick envelope in the post. It contained every one of my spelling mistakes over the six years I had been there. A retired teacher had underlined in red all my errors; in particular the misuse of affect and effect. I wasn't sure whether to be offended or flattered! How easy it is to remember the harsh offensive words or actions we have been wounded by?

If we are not careful, they sit on our shoulders and can weigh us down. I have learnt to literally shrug my shoulders when this happens and to pray a blessing on the one who has (sometimes unknowingly) upset me. I know it does me no good to keep dwelling on the wrongs. Words can hurt like fiery darts, but loving despite the hurts, can quench them, remove the sting and harmful *effect* they have.
I got it right in the end!

Day Seventy-nine

"Set your minds on things that are above."
Colossians 3: 2

There's no doubt we are in a battle right now. The world is fighting against a virus none of us had heard of this time last year. We face many battles in life. Perhaps the biggest one we fight on a personal level, is the battle in our minds, particularly regarding our thought life. So many things demand our attention. But we need to be careful what we think about.

The more we think about the things that build us up and are good, the better our lives will seem. Experts believe that the mind thinks between 60,000 and 80,000 thoughts a day which works out to be about 2,500-3,300 thoughts an hour!

Mahatma Gandhi said this: *"A man is but the product of his thoughts. What he thinks, he becomes."* Our thought life is powerful. Let's try and win our own battles against the negatives that threaten to steal our joy.

" I will sing the
Lord's praise for
he has been
good to me."

Psalm 13 : 6

Day Eighty

"I will sing the Lord's praise
for he has been good to me."
Psalm 13: 6

Following on from yesterday's leaf picture which looked at the battle in our minds, I find the best antidote to thinking too much, is to be thankful. I have a sticky note on my computer that says: *'thank more, think less.'* It keeps me in check, although of course there are days when I think more, and thank less.

In order that I don't get lost when I am out running, cycling or walking, I look out for landmarks. In life, we all have important landmarks - key events which made us happy, or were pivotal in changing our attitudes, work or everyday living. In this current season, many of us are grateful for the little things - a phone call, a cup of coffee, some flour to bake with or beautiful weather. As we focus on the goodness around us, we realise there is so much to be thankful for.

It's easy to complain; it takes a lot of faith and effort to keep up a thankful attitude.

"Though they stumble, they will never fall, for the Lord holds them by the hand."

Psalm 37:24

Day Eighty-one

"Though they stumble, they will never fall,
for the Lord holds them by the hand." (NLT)
Psalm 37: 24

I have always associated the act of kite flying with parenthood. When children are small, they (the kites) need to be nearer the ground, where they can see us for that reassurance. We are the anchor and without us they can't fly. As teenagers we need to let them explore their own giftings, talents and strengths whilst being close at hand if they need us. As they venture into adulthood, we let go even more as they learn to become independent.

Yet they know we are cheering them on and at hand for advice and support. In our spiritual lives, we are the kites attached to an invisible string. When we trust the one holding the other end, we are free to soar, to use our gifts and talents and be everything we were designed to be.

If we cut ourselves off from the string we are in danger of nose-diving into the ground below. In order to stay flying, we need to stay connected. And when it gets a bit hairy, perhaps we should just tug at that string and cry *"Help!"*

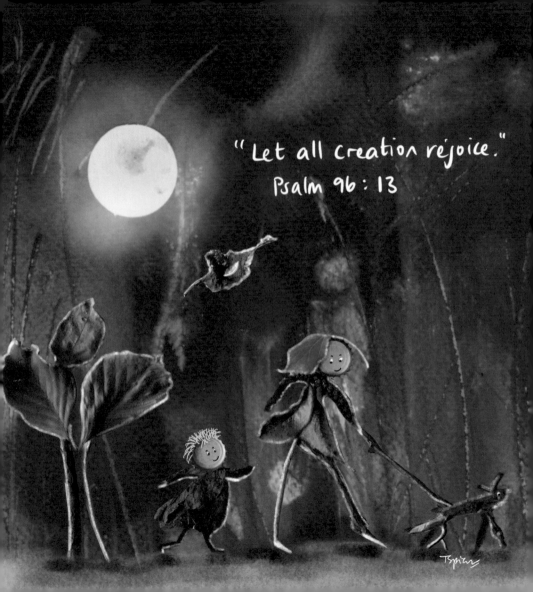

Day Eighty-two

"Let all creation rejoice."
Psalm 96: 13

Bird song is one of the sounds we will remember from lockdown. It's not that we didn't hear it before, it's just that due to lack of traffic both upwards and on our roads, the birds' melodic voices have been magnified. It led me to investigate the reasons why birds sing.

Unlike animals which apparently are born knowing the sounds they need to communicate, baby birds spend a lot of time learning how to sing by listening to the way their mums and dads do it. It takes time and effort to perfect complicated songs. For that reason scientists think birds sing to impress other birds as well as for fun. It is also for territorial and mating purposes.

If a small creature like a bird can make such a beautiful sound, then surely we can at least try - even if it is just in the shower. Let's join creation in praising the Creator.

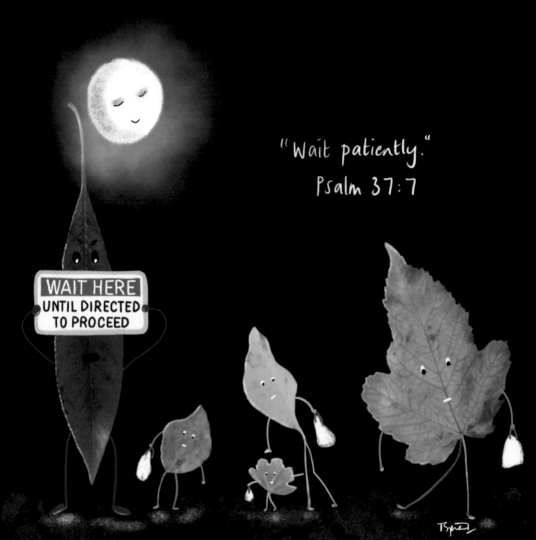

Day Eighty-three

"Wait patiently."
Psalm 37: 7

There are two words that I struggle with and that's *"wait"* and *"patience"* so the phrase *"wait patiently,"* is not something I find easy. I was born (the wrong way round!) almost a month early and am always ahead of myself.

For many of us, this season is like waiting in the wings, ready to go back on stage but not really knowing what our cue is or when it will happen. Will we remember our lines and will our performance be good enough when we do? Waiting is hard - whether it is waiting for results, desires to be fulfilled, prayers to be answered or simply waiting in a queue to do our shopping. From experience, I know to trust God's timing because it is always perfect.

The answer is not necessarily *"No!"* it is often *"Not yet."* God's goodness is promised for those who wait patiently for him. When we know He has our best interests at heart, it is easier to trust. But trust like patience takes time to grow in our lives. I am not there yet, but I am learning.

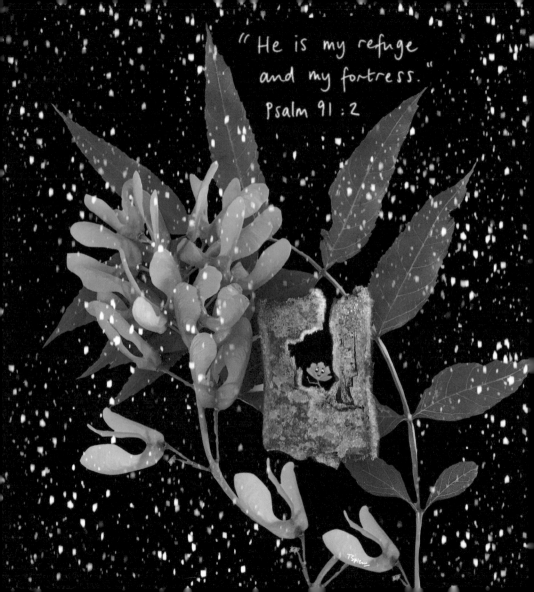

" He is my refuge and my fortress."
Psalm 91:2

Day Eighty-four

"He is my refuge and my fortress."
Psalm 91: 2

Psalm 91 has been well quoted amongst churches during the pandemic. It is a beautiful song that speaks of trust in God in dark times. In it are references to plagues and diseases which is appropriate to what the world is currently facing. I found these leafy items - including the piece of bark - on a recent walk with my youngest daughter and it looked like a mini fort. We carefully carried it home.

I didn't realise that my leaf series would become a unique record of what has been a unique season. I guess Psalm 91 has meant a lot to many during this time. It has been a period of sadness and uncertainty, but more and more people have returned to prayer in recent weeks.

Despite what we see, God is real and He is faithful. I am sure there will be many testimonies of how He has been a personal refuge and tower of strength during this pandemic storm.

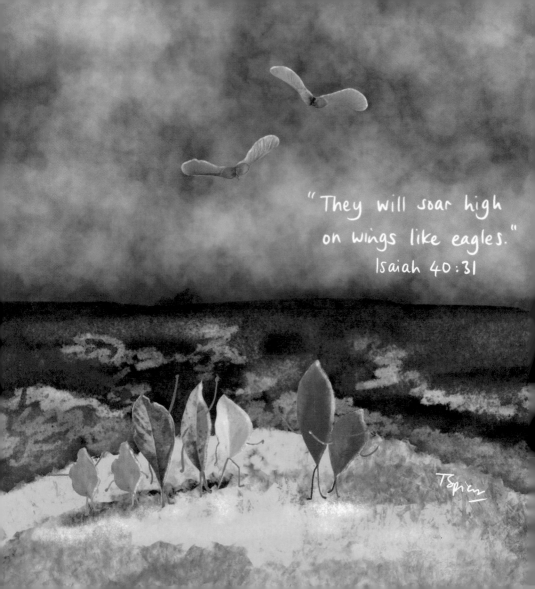

"They will soar high on wings like eagles."

Isaiah 40:31

TSpier

Day Eighty-five

"They will soar high on wings like eagles." (NLT)
Isaiah 40: 31

The other day, my daughter and I were watching a crow annoy a bird of prey. It kept coming right up behind and was obviously pestering him. The crow in its defence was protecting its territory. The only way the bigger bird could outfly the crow was to ride a thermal.

Yesterday, my husband and I went for a walk with our five daughters. Our eyes were drawn upwards as two buzzards effortlessly soared higher and higher above us. They were lifted by the thermals and did not need to use their wings at all. It looked easy and even from a distance we could see that they had perfected the art of waiting and letting the thermals lift them.

Similarly, the way to ride above the thermals of life, with its challenges and trauma, is to stop flapping in our own strength and to trust God's spirit to lift us. In Greek, the Holy Spirit is called *'pneuma'* meaning current of air. We need to learn to wait for that current of air to lift us up. It isn't always easy and it takes courage to wait.

"Never tire of
doing what is good."

2 Thessalonians 3:13

Day Eighty-six

"Never tire of doing what is good."
2 Thessalonians 3: 13

Today's thought celebrates the smallest migrating bird, the hummingbird - the only bird which can fly backwards. It can't however smell, walk or hop. There are over 330 species of hummingbird and various collective names for them including bouquet, glittering or tune.

Yet unlike other migrating birds, a hummingbird often migrates alone, travelling up to 500 miles at a time and at a speed of up to 30MPH. So named because it makes a humming noise as its wings beat so fast. It only weighs about five grams - the equivalent of five paperclips.

Why do I highlight this little feathered friend? Because it is one of God's tiny miracles, emblematic for its energy and vigour. It has stamina, it doesn't give up and during turbulent airflow conditions, a hummingbird has a stable head position and orientation. It knows where it is going and has the ability to endure. I want to be like that.

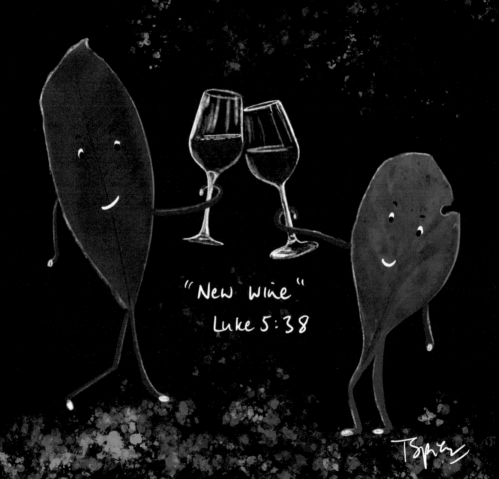

Day Eighty-seven

"New wine."
Luke 5: 38

My late uncle was a wine connoisseur. He knew his wines and one Christmas he decided to open up one of his vintage treasures, a 25-year-old bottle of red wine. He gave us a lesson in tasting it and we collectively raised our glasses. It was absolutely awful. It had gone off and he was grateful that his family was tasting it and not his wine circle chums!

Today my thought is on new wine. This verse refers to the fact you can't put new wine into old wineskins. We are very much in a transition time. We can't go back to our old life and we are unsure what the new one will look or feel like. The challenge is to take the good things and lessons we are learning into this new season.

New wine is created after a lot of crushing and pressing. It isn't comfortable but it produces great results. Let's not be afraid to embrace this new wine. It may taste better than the old.

"Walk by faith,
not by sight."

2 Corinthians 5:7

Day Eighty-eight

"Walk by faith, not by sight." (AMP)
2 Corinthians 5: 7

One of the best visual illustrations that depict faith in my opinion, is a scene from the 1980s classic Indiana Jones' film *The Last Crusade*, when Indy has to take the *"walk of faith"* across a deep ravine which has a drop that falls away to nothing. With courage, he steps out into the scary unknown. It is only as he does so that the path ahead becomes clear. He can not see it in the physical. He has to believe, step out and only then does it become something he can follow.

If you have a dream or feel called to do something, don't give up when you can't see the pathway in front of you. Just take one step of faith at a time and it will become clear.

In 2013, I felt it right to go to university despite being 28 years older than my fellow illustration students. A first class honours degree and an MA later, I am starting to see the road opening up before me. Don't give up.

"The Lord is close to the brokenhearted." Psalm 34:18

Day Eighty-nine

I am conscious that looking back at this time, lockdown will mean different things to different people. For some it will have meant home schooling, juggling work and family like never before; for others it will have been an exhausting, emotional time working on the frontline as a key worker; for another group it will be regarded as a time of resetting, stopping, reflecting and enforced rest; and for some it will have been a time of heartache, sadness and loss as loved ones have passed away without the chance to say a proper goodbye.

I believe when we mourn, God mourns with us. The Lord's Prayer begins with *"Our Father"* and God is often referred to as *"Abba"*, meaning Daddy. A loving father will always care about his child. As a parent, I share my children's pain and joy. If they hurt, I hurt and I can only reassure them that they are not alone in it.

I believe God has a very special place in his heart for those who are broken-hearted.

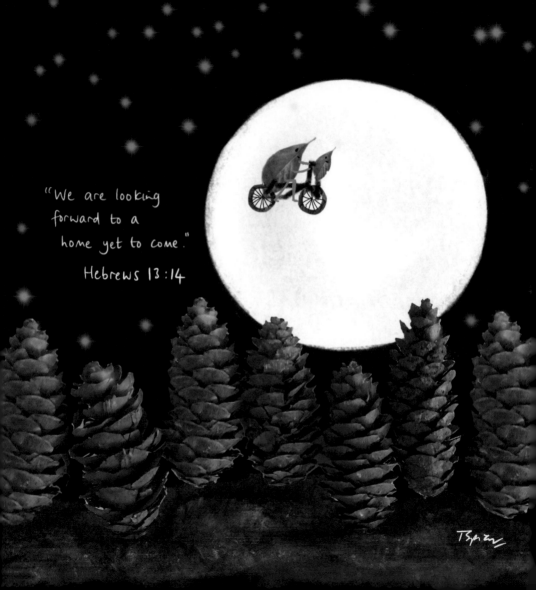

"We are looking forward to a home yet to come."

Hebrews 13:14

Day Ninety

After picking up a few pine cones and arranging them on my desk, I couldn't help recreating this iconic scene from Steven Spielberg's 1982 classic, *E.T. The Extra Terrestrial*. It shows my age, but I grew up with this film. An alien botanist befriends a 10-year-old boy called Elliott, who helps E.T. phone home and be reunited with his family.

Whilst it may be a science fiction film, it deals with everyday emotions and experiences: broken families, loneliness, friendship, and love. But it also highlights a hunger we all have for a relationship with someone beyond our world.

This is but a temporary home. It is isn't our final destination. Like E.T., we can all feel lost sometimes and out of place. But we can phone home anytime, anywhere. It's called prayer and the lines are always open.

Day Ninety-one

"Perfect love drives out fear."
1 John 4: 18

Understandably there will be a few apprehensions and concerns this morning as some of our children return to school - but not as they knew it. Many teachers and TAs have already been faithfully helping vulnerable children and those belonging to key workers.

As nursery children, Reception, Year 1 and Year 6 return to their classrooms, it will be hard for them and their teachers to keep their distance. We are designed for physical touch. It gives reassurance. My prayer is for all those who are teaching with new restrictions, that they will find creative ways to show they care, maintain their humour in the tough times and encourage one another to keep strong.

I hope parents now have a fresh appreciation for those who do their best to steer young people through their education journey. School staff we salute you.

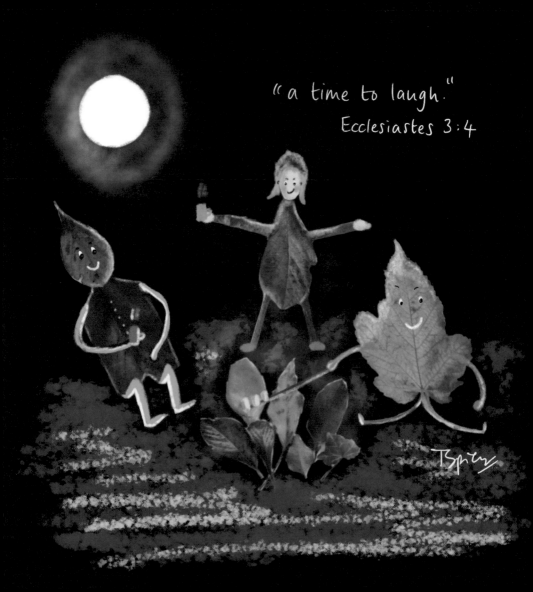

Day Ninety-two

"...a time to laugh."
Ecclesiastes 3: 4

One of the best tonics in life is to laugh, and to laugh with friends. I mean really laugh. Spontaneous laughter is infectious and causes everyone else to laugh too, so much so that no one can remember what it is that they are actually laughing about. We are created to love one another and to enjoy communicating over simple things such as campfires. My children were looking forward to camping trips with their friends. But like so many social events, they have been cancelled. Yet it hasn't stopped my girls laughing.

I have been blessed by the sounds of laughter in my house as they have shared funny moments with their friends and with each other. As restrictions start to lift, let us reclaim that precious gift that money can't buy - laughter.

And if you haven't used it for a while, ring or meet up with someone you know who will help you chuckle again.

"Your will be done
on earth, as it is in
heaven." Matthew 6:10

Day Ninety-three

"Your will be done on earth, as it is in heaven."
Matthew 6: 10

I've been up in a glider, a hot air balloon and had a go at parasailing, reaching dizzy heights attached to a wire connected to a speed boat beneath. I've decided when I am in my nineties that I might have a go at wingwalking, because by then I might have forgotten that I am actually afraid of heights! Watching paragliders high above us the other day, helped me think about perspective.

My friend and I were standing below in the same vicinity, but what the paragliders saw from high up, was a very different view to what we could see. In Scripture it says that God's ways and thoughts are far higher than ours. He sees the full picture. We only see in part. So when we say the Lord's Prayer, *"thy will be done on earth as it is in heaven,"* we are acknowledging that we need God's perspective and His divine help to sort out what is wrong around us.

As it's His prayer, we can have confidence that He wants to answer it.

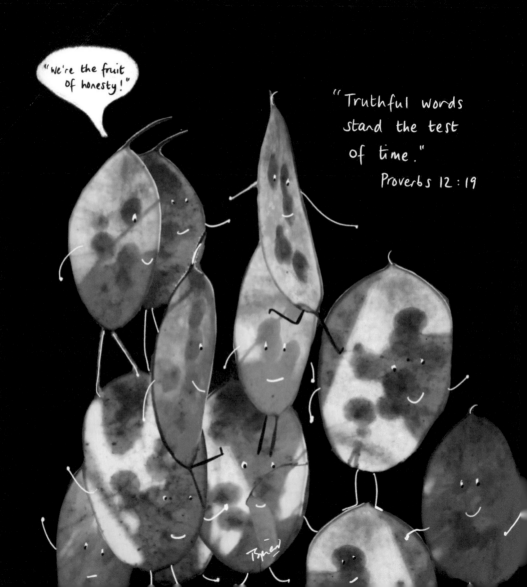

Day Ninety-four

"Truthful words stand the test of time." (NLT)
Proverbs 12: 19

On day 48, I paid tribute to the plant "honesty", which pops up a lot in hedgeways in spring. Today though as time marches on, the beautiful purple flowers have gone to seed. The seed heads of honesty look like golden coins and as the sun shines through them you can see the seeds within.

Their translucent papery pods are often dried and used in flower arranging. I was chuffed to find out that honesty is part of the brassica family and therefore related to my favourite vegetable, broccoli. What's great about honesty is that it stands out whether it is in flower or in seed - or even dead. Like the plant, the virtue of honesty (or speaking the truth in love) should be something that we aspire to act out in all seasons.

But living a life of truth, isn't just about words, it is about what we believe. It is a spirit-level by which we can check everything is in line and consistent.

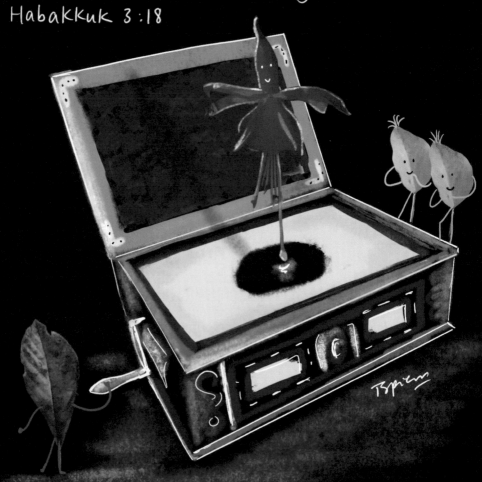

Day Ninety-five

"I will be joyful in God, my Saviour."
Habakkuk 3: 18

My family knows that I am not green-fingered and almost laugh out loud when friends give me flowers. I am not very good at looking after them (the flowers not my friends) and have been known to water artificial plants when asked to house sit. However lockdown has helped me appreciate nature's joys and I have found myself admiring the detail and colour around me.

I particularly love this dancing ballerina - the hardy fuchsia - which is bouncing daintily in my parents' garden. It reminds me of the musical jewellery box I had as a child. As you lifted the lid, the ballerina would stand to position and twirl as the music activated. It was a specific tune.

I may not be able to dance so elegantly, but my heart can dance. We all have our way of doing life, we have a personal song and a unique purpose which fits us. As the lid of lockdown lifts, let us not be afraid to dance to the song in our hearts.

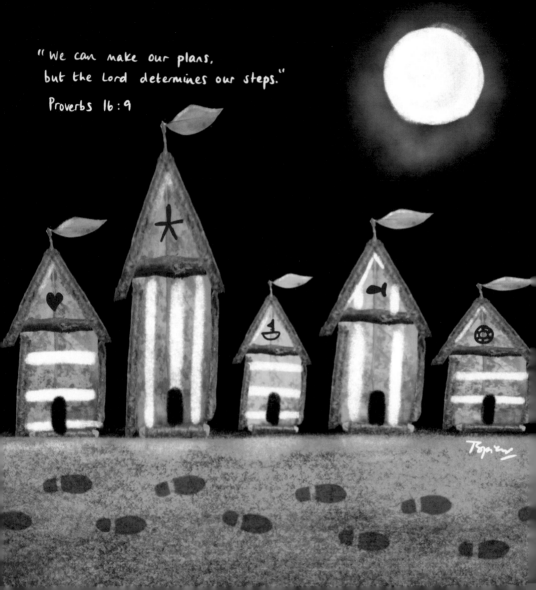

"We can make our plans,
but the Lord determines our steps."

Proverbs 16:9

Day Ninety-six

"We can make our plans, but the Lord
determines our steps." (NLT)
Proverbs 16: 9

I was chatting with a friend yesterday about countries we had been to and the memories connected to them. A year ago I was in Corfu, running every morning along the picturesque coastline and enjoying the Greek culture with my friends for our 50th birthday. This year I would be as happy with a bucket, spade and a sandpit in my garden if it meant I could be with those I physically miss.

The word 'holiday' may be temporarily rubbed out of our dictionaries this summer and that's hard. What was meant to be a summer full of weddings, festivals and celebrations won't look as we had hoped. There's a heaviness and a weariness about, but my prayer is that we find new creative ways in our thinking, actions, time management and meeting together.

There is always a way forward and when we are tired, it's then we look back and realise we have been carried.

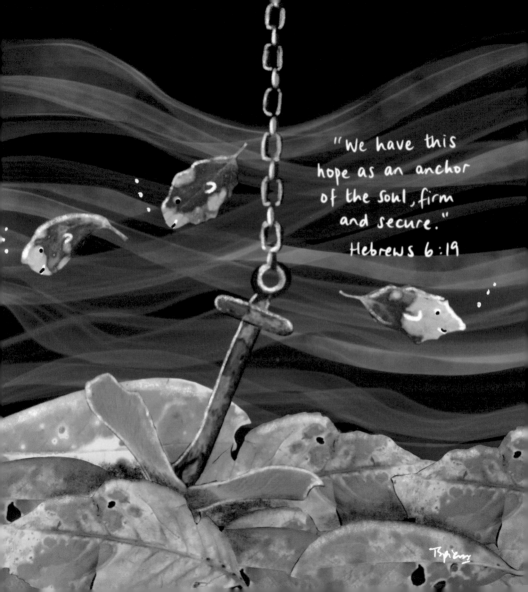

Day Ninety-seven

"We have this hope as an anchor
of the soul, firm and secure."
Hebrews 6: 19

There's no doubt that the storms of change have become our new norm. We can see it two ways, either as a scary, unfamiliar place where we are buffeted by waves and we lose our orientation; or we can see it as a wild adventure, an opportunity to refocus, come out of mediocrity and explore new avenues in the way we do things. The latter is not so easy.

We are all familiar with the concept of an anchor in its nautical sense. During heavy winds or currents, it stops the vessel from drifting away by fixing it in a certain position. In this storm, which will be recorded in history, many people have returned to prayer.

In our Christian walk, Jesus is our anchor and because He is holding us firm, we can turn our trembling into trust and know that the boat we are in, may be buffeted, but it will not be broken. The storms are after all what the anchor is for.

"He comforts us in all our troubles
so that we may comfort others."

2 Corinthians 1:4

Day Ninety-eight

"He comforts us in all our troubles
so that we may comfort others." (NLT)
2 Corinthians 1: 4

Living in a town surrounded by five valleys, there are plenty of hilly climbs and amazing views to enjoy. Whilst up on the hilltops, we can see folk below, and similarly whilst in the valley bottom we spy tiny pin-head figures walking on high ground. In our lives, we each walk through the emotional valleys of grief, disappointment and fear. We also have seasons where we experience the mountain tops of rejoicing, celebration and fulfilment.

The same God who celebrates with us on the high ground, is the same God who shows compassion in the lowest of valleys. When Moses was battle-weary and needed help, Aaron and Hur came to his aid by lifting his arms. We all need a helping hand at times.

Not one of our life experiences is wasted, because inevitably we will help someone who is going through the same difficult valley we ourselves have walked through. What seems awful at the time, can be used for good when we become the support and comfort for those who need it.

"Suppose one of you has a hundred sheep and loses one of them? Doesn't he leave the ninety-nine in the open country and go after the lost sheep until he finds it?"

Luke 15 : 4

Day Ninety-nine

"Suppose one of you has a hundred sheep and loses one of them? Doesn't he leave the ninety-nine in the open country and go after the lost sheep until he finds it?"
Luke 15: 4

As it is day 99, there is only one verse I can choose and it relates to the story of the shepherd, who realising he had only 99 of his flock, left them in the field, to search for the one that was missing. He didn't stop looking until he had found the lamb. He then lifted it on his shoulders and carried it home to safety.

I remember momentarily losing one of my five children. I knew they had all got into the car to come home, but after being in the house for 20 minutes, I realised one of my twins was missing. Panic set in and I got her siblings to help me look everywhere - the car, every room, every hiding place. We couldn't find her. But then I felt the need to look in the car again, and there in the very back, crouched down in the darkness, huddled up in a ball, was Rosie. *"You left me behind,"* she said. I felt dreadful, and hugged her tightly. I had lost her but what struck me more, was that I would be lost without her. Jesus is known as the Good Shepherd. The story says it all. He will do anything to seek us out because He too says He is lost without us.

Day One Hundred

I started lockdown immobile, unable to walk let alone run. Having run for 35 years, to get a stress fracture on my heel was not my finest achievement. But it has made me realise that my race in life doesn't have to be fast. I just need to finish.

After snapping his hamstring during the 400m semi-final race in the 1992 Olympics in Barcelona, Derek Redmond realised his dream of gold was over. But his dad, Jim, went to his aid. In immense pain, with courage and determination, Derek crossed the finish line with his dad's help.

We all have our race to run. We may have had a poor start, suffered injury along the way, but we all have the ability within us to finish well. Our Christian race is not a sprint, rather it is a long-distance run. We need to train well, keep our spiritual muscles active, allow those who have gone before us to cheer us on and if we find ourselves faltering, we need to know that our Heavenly Father will help us cross the line.

"I will sing the lord's praise, for he has been good to me."
Psalm 13:6

Day One Hundred and one

"I will sing the Lord's praise,
for he has been good to me."
Psalm 13: 6

Sixty years ago the robin was declared as Britain's national bird. It is one of the first birds to sing in the morning and one of the last to sing at night. This week, my sister who has a unique way with animals, lovingly saved a robin's life. Its nest was destroyed by a cat and all of its siblings were killed. A neighbour brought the surviving bird to her that evening to see if she could help and she stayed up most of the night with it. We prayed the robin would survive and amazingly it did. In the morning my sister was able to locate its original territory. The mum recognised her chick's call and was there immediately to welcome it back. His dad followed not long after.

God loves family. He longs to reunite, restore and rekindle a love between family members. We are designed to be a community and God hears the cry of our hearts.

"Now to him who is able to do immeasurably more than all we ask or imagine." Ephesians 3·20

Day One Hundred and two

"Now to him who is able to do immeasurably more than all we ask or imagine."
Ephesians 3: 20

I have been challenged lately in my prayer life to raise the bar of my expectations. Sometimes I think we limit ourselves and what we pray by past experiences. Maybe we didn't see an answered prayer, or perhaps it was answered, but not as we would have liked. We don't see the full picture so cannot fully understand the whys. But God's ways and thoughts are far higher than our human minds. Despite what we see around us in the physical, I believe this is a season to press in even more and expect greater things. Let's believe for healing in our nations. Let's raise the bar for what we expect to see.

I like the The Passion Translation's version of this Bible verse, which puts it like this: *"Never doubt God's mighty power to work in you and accomplish all this. He will achieve infinitely more than your greatest request, your most unbelievable dream, and exceed your wildest imagination!"* I don't want to settle for this new norm, I want to see big prayers answered.

Day One Hundred and three

"Each part does its own special work." (NLT)
Ephesians 4: 16

Like many households, our kitchen has become a *Bake Off*, where new recipes have been tried and tested, including this amazing creation by our eldest daughter. Trying to locate the ingredients was not an easy task or a cheap one! Four supermarkets and two local shops later, she was able to start mixing her masterpiece. Every ingredient mattered - the eggs, vanilla essence, self-raising flour, unsalted butter, brown sugar and of course the Lotus Biscoff spread. If one of these things was missing, the cake wouldn't have worked. Similarly on their own the ingredients wouldn't have tasted right.

Every one of us is special and unique. We all have a place and a part to play whether that is in our families, community, churches, work environment or in the world. We are individual, but we are interdependent. We have a responsibility to encourage each other in the giftings we have because we are all needed to produce good outcomes. And yes, the cake tasted as good as it looked!

"He refreshes my soul."
Psalm 23 : 3

Day One Hundred and four

"He refreshes my soul."
Psalm 23: 3

In the early 1990s I spent many months in Fiji with Youth
With A Mission. I spent half of that time teaching in a
primary school and visiting sick adults and children in a
burns unit at the local hospital. I was up at 4.30am making
roti and curry for the family I was living with at the time as
the mum had had a cataract operation. It was an exhausting
time and one morning as I prayed for strength, a picture of
an icecream came to my mind and a quiet reassurance that
I would be refreshed that day. After a long day at school,
I visited the burns unit as usual. It was really hot outside
and the icy cold temperature in the hospital was welcome,
so much so I fell asleep by accident for three hours! When
I returned back to my host's house, I was handed a bowl of
icecream.

I couldn't quite believe it as I had not been given it before
and never had it again. I believe the Lord longs to refresh
the weary, but we have to stop striving and let go. I was
really refreshed that day.

Day One Hundred and five

"With my God I can scale a wall."
Psalm 18: 29

In the early days of my journalist career back in the 1980s, I spent the day with the army along with other reporters all over the country. We were put in teams and our task was to get round an assault course in the fastest time. Being the only female, I didn't want to let myself down; but as I am only five foot, I knew the 12 foot wall would be my greatest challenge. However with my teammates urging me on, my determination to fulfil the task and my ability to pull on the rope to get up, I managed it and we won the prize - a crate of beer.

There are many walls we face in life. It would be far easier to knock them down, but often we have to embrace the challenge of scaling the wall. Why? Because the act of climbing, strengthens our faith muscles. It's as if the Father is whispering this to us: *"this mountain face you climb, is hard my child I know, but trust me I am at the top pulling the rope you hold."*

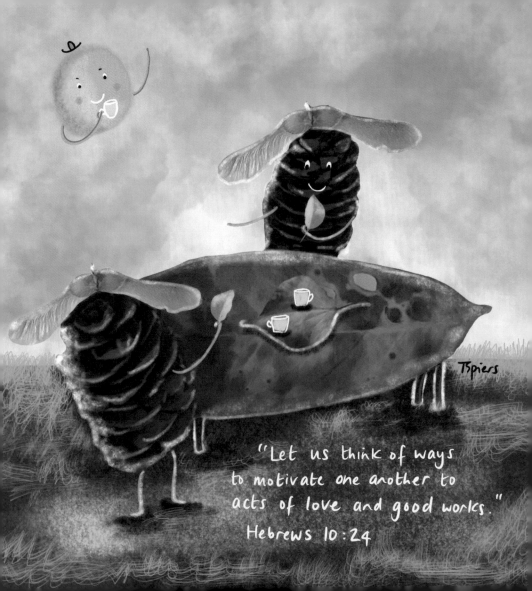

"Let us think of ways to motivate one another to acts of love and good works."
Hebrews 10:24

Day One Hundred and six

"Let us think of ways to motivate one another
to acts of love and good works." (NLT)
Hebrews 10: 24

Visiting friends' houses has become a totally new concept in this current season. As our garden can only be accessed by walking through the house and we are a family of seven, to host 'up to six people' in our garden is impossible!

So I have taken to meeting friends in their gardens. Of course it does mean there's no longer the sudden urge to clean the interior of our homes before guests arrive. I am surely not the only one to do this?! Nowadays, however we just want to see a familiar face even if it is at a two metre distance. But I have equally appreciated one-to-one zoom calls and text messages. Conversation seems to be more real, honest and we get to the point of the matter. And I am finding that there has been far more heart-to-heart talking and a sincerity to what we say.

Just as we need encouragement, we too need to be encouragers who are willing to cheer those we can and cannot see on. We are after all in this together.

"Listen very carefully to the truth we have heard."
Hebrews 2:1

Day One Hundred and seven

"Listen very carefully to the
truth we have heard." (NLT)
Hebrews 2: 1

I learnt how to safely cross the road using the Green Cross Code, a procedure which consisted of the words: *'stop, look and listen.'* The same wise words can be used in many situations to help us avoid making unnecessary mistakes. They have certainly helped me to not make important decisions in haste. Instead, I have found myself prayfully considering my options by getting away from the noise and being quiet. When we come to a railway crossing, a zebra crossing or any dangerous place, we are meant to stop. They are signs which act as a warning.

In the Christian faith, Scripture and prayer are there for our own protection. They help us stay on course and if we want to grow, we need to take note of them. As a physical parallel, during this season many of us have been forced to stop, look at our surroundings with fresh appreciative eyes and listen to nature's joyful sounds. When we are too busy and surrounded by noise, we so easily miss out on what's important.

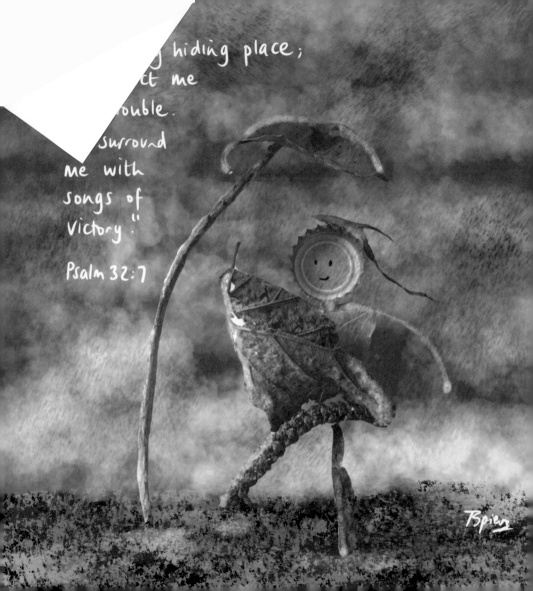

Day One Hundred and eight

"You are my hiding place; you protect me from trouble. You surround me with songs of victory." (NLT)
Psalm 32: 7

After weeks of glorious weather, heavy downpours come as a shock. As I write this, some of our local towns have been flooded as drains haven't been able to cope with the sudden torrent of water. On a personal level, we have had water pouring into our bedroom and paint is now no longer on the wall, leaving the plaster exposed. When we are not prepared, a sudden change can knock us. We all know that only too well. But in life, as in the weather, situations happen that haven't been forecast and it is just too much for our flimsy umbrella covering. It's in these times we have to be a strong covering for each other and be a refuge for those who need it.

Spiritually speaking, the Bible tells us when sudden storms of life overwhelm us we will be kept safe and that the Lord is our secret hiding place. Yet I am also aware there are days when we can't grasp this truth and all we need is someone to give us a hug. Some hugs are well overdue.

"Let the weak say, "I am strong.""

Joel 3:10

Day One Hundred and nine

"Let the weak say, "I am strong."" (NKJV)
Joel 3: 10

I know I am not perfect. I know my body is not perfect too. It bears the stretch marks of carrying twins for one thing and I have a lot more laughter lines than I would like. But they are evidence that I have lived and laughed and they are unique to me. Due to water damage and general wear and tear, our house has a lot of cracks and marks we would prefer it not to have. But I have felt challenged to see these marks from a different perspective.

We shouldn't despise the cracks and imperfections. Rather we should see them as opportunities to identify what needs to be repaired or restored. Cracks also show us where we have outgrown something. They are a symbol of expansion. A chick cracks the egg shell when it can no longer fit and has to move into bigger space.

Instead of despising the cracks and seeing them as a sign of weakness, maybe we should see them as an opportunity to gain strength and grow.

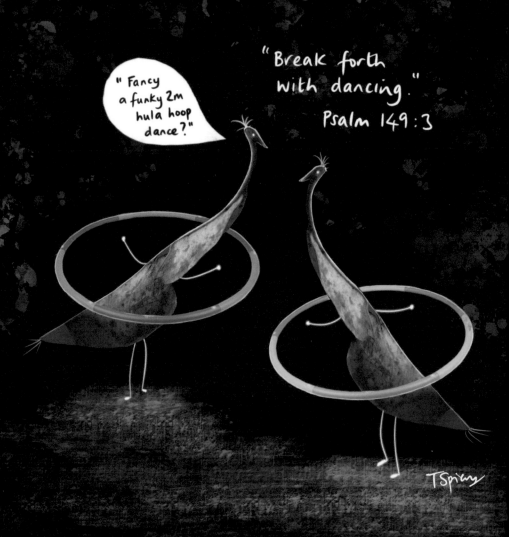

Day One Hundred and ten

"Break forth with dancing." (TPT)
Psalm 149: 3

In recent weeks, one of the tasks my twin daughters were set during their on-line learning sessions with school was to create a device that would be helpful during a pandemic. One of them designed an outfit that helped you remember what day it was, whilst the other came up with the Corona Belt. The aim being when out, you pressed a button and a two metre diameter hula hoop surrounded you for protection.

Growing up in the 1970s, the hula hoop was one of my favourite pastimes but its origins go back to Ancient Greece where it was used as a form of exercise. My Corona Belt designer also set herself the challenge of juggling three balls whilst hula hooping. It's the sort of thing you master during lockdown!

So what's my thought for today? Give yourself permission to play. Do something different and if you want to dance with friends at a safe distance, do so with a hula hoop. Let's lighten the heaviness today with fun.

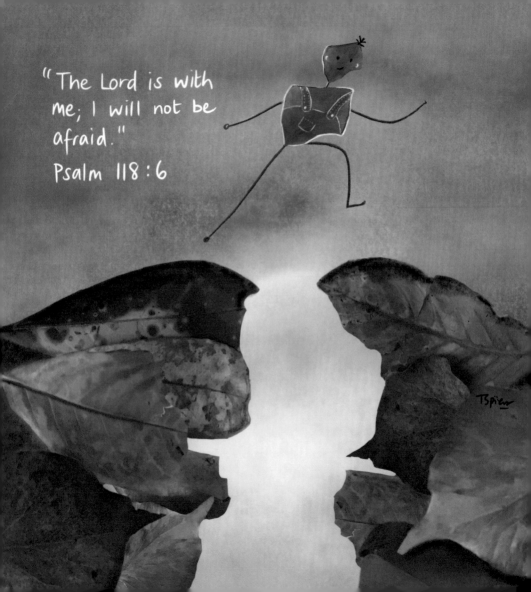

Day One Hundred and eleven

"The Lord is with me; I will not be afraid."
Psalm 118: 6

Peter is one of my favourite characters in the Bible. He got things wrong, he was impulsive, but he was passionate and refused to conform when culture didn't line up with truth. This ordinary fisherman did extraordinary things, he walked on water and after Pentecost, was instrumental in building the early church. He knew his God was with him.

As our towns start to come alive again and shops reopen, let us go out with courage. Many are afraid to step out into this new normal, but whilst we need to be alert, we shouldn't let fear take over. Our local shops need us, people need us to engage with them again.

Giving a reassuring smile to someone in the street or on the towpath can be the best gift you can give. It may not be walking on water, but it is a step in the right direction.

Day One hundred and twelve

"Keep me as the apple of your eye."
Psalm 17: 8

I have often wondered what the phrase *"apple of my eye,"* means. Doing some research, I discovered that it comes from a Hebrew expression that literally means *"little man of the eye,"* and refers to the tiny reflection of yourself in another's pupils. It means that you are being closely watched by that person and your own image is dancing in their eyes. In modern English, the phrase indicates something or someone that one values above all others.

But today's verse was actually a request from King David asking God if He would keep an eye on him and regard him as one would of a loved child. David knew that to be the apple of God's eye meant that he would be at the very centre of His focus and protection. We too are the apple of God's eye. He loves us far more than many of us realise.

Day One Hundred and thirteen

"Be patient in trouble and keep on praying." (NLT)
Romans 12: 12

With lockdown restrictions changing and activity starting to increase in our town centres as shops reopen after three months, more people are venturing out of their homes. But many aren't and won't until further reassurance is given.

There has been an unspoken feeling whispering, *"is it safe to come out yet?"* It's against our nature to cross the road if someone comes towards us on the path, awkward dodging takes place and it is hard to acknowledge friends if they're wearing a face mask because we don't recognise them.

Whilst it is safe to go outside, we still do so with caution and we take care not to violate restrictions. It all feels wrong because we are a tactile people. However let's try and remain patient especially when queuing(!) and keep praying for each other, for our nation(s), for those who are making decisions and for those trying to find a cure.

"Nothing can ever separate us from God's love."
Romans 8:38

Day One Hundred and fourteen

"Nothing can ever separate us from God's love." (NLT)
Romans 8: 38

I have always wondered why penguins have wings but can not fly. Apparently they used to be able to fly, but because their survival rate against predators was better if they used their wings as flippers and swam, they lost the art of flying. The more efficient they became in water, the less efficient they were in the air.

They can swim up to 20MPH in the ocean! We are all good at something, the key is to find out what that is and strengthen that skill so we can use it to bless others. Today's message celebrates the penguin and his adapted skill, but I also realised that most penguins are one metre high - likely to be the next social distance between us.

Penguins however do not social distance and in fact the Emperor penguin has perfected group hugs to keep everyone warm in freezing conditions. Let's hope by winter, we can too. I am grateful that God doesn't social distance. He is always close. It is up to us how distant we are from Him.

Day One Hundred and fifteen

"Come and see the works of God." (NKJV)
Psalm 66: 5

Today's thought revolves around the starfish or sea star, which has an incredible ability to regenerate. They don't have blood or a brain and whilst they are only as big as a teacup, they can weigh up to 11 pounds and can live for 35 years!

These sea stars also have the capacity to grow another arm within a year if they lose or break one. Another fascinating fact is that they eat from the inside out. The Christian message is all about new life and rebirth which works from the inside out. It is mind-blowing. At the moment it can feel like we have lost a limb be it physical, economical or emotional.

But we have to remember that the same God who created the starfish, will regenerate our lives if we allow Him to work from the inside out. It does however require a mind shift.

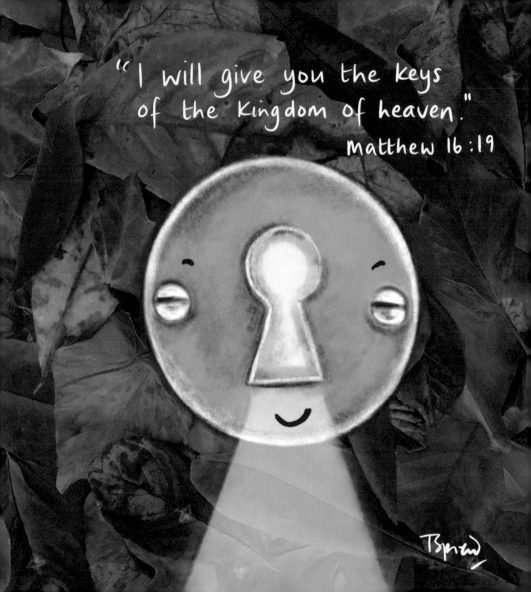

Day One Hundred and sixteen

"I will give you the keys of the kingdom of heaven."
Matthew 16: 19

After years of putting up with a rotten door frame and shabby looking door, we are finally getting a new one. The salesman asked us, *"So how many keys will you need?"* We opted for ten, one for each of our household, one for our lovely neighbours who always rescue me when I lock myself out, one for my parents and one spare.

New doors require new keys and once the old door has gone those keys are useless. We have an open invitation into a different kingdom which requires a different way of thinking - it's a culture of love, joy, peace, patience, goodness, gentleness, faithfulness, kindness and self-control.

To show this kingdom we need to live it out. However we can only do that if we have the right key. Try in our own strength, we fail. Only when we work in partnership with God can we see this happening. We need only to ask for the key.

Day One Hundred and seventeen

"But I focus on this one thing: Forgetting the past and looking forward to what lies ahead." (NLT)
Philippians 3: 13

Years ago when my oldest three children were all under the age of five, we walked past a coffee shop that was opening for the first time where staff were handing out balloons. Each of the children happily took one. As daughter number three was only about one, I tied her balloon to the pushchair. As we got back to the car, the inevitable happened. The balloon became untied and up it went. Immediately the children who could speak, shouted: *"Mummy, Mummy get the balloon!"* I thought about pressing my superpower button and shooting into the clouds to get it, but thought better of it and decided to let the balloon fly free. My older children were inconsolable whilst the child who it belonged to didn't mind at all.

Sometimes we have to let things go. What this season has taught us is that we can't go back, we have to go forward. Let's try and let go of what was and instead courageously walk ahead with fresh boldness and renewed faith.

Day One Hundred and eighteen

"Now you are the body of Christ and
each one of you is a part of it."
I Corinthians 12: 27

Being a mother of five delightfully different daughters helps me understand that despite the fact they all carry mine and my husband's DNA, they are each unique in appearance and in what they are gifted in. The church is the body of Christ. It is not a place we go to worship and meet, it is a group of ordinary people who follow an extraordinary God.

Just because our churches have been shut, it hasn't stopped the act of worship, prayer or indeed us meeting together. We have just done it virtually from our homes. Every member of God's family is important, each shows an expression of who He is, so no one can boast they are more valid. The church works best when everyone plays their colourful part.

Everyone carries the DNA of love, and when that is allowed to be expressed through the unique gifts of each member, then we become the church we are called to be.

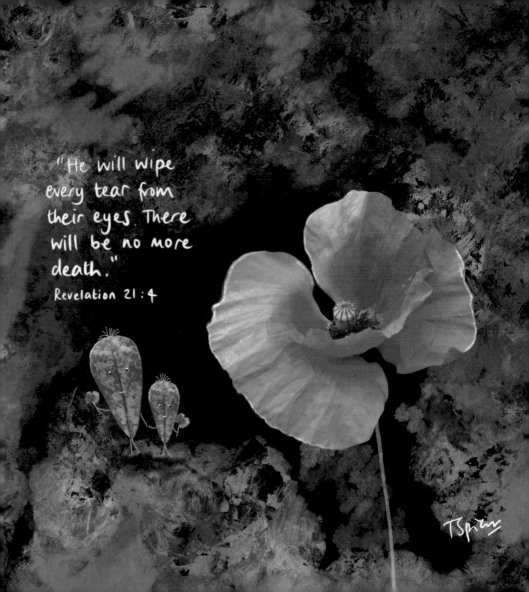

Day One Hundred and nineteen

"He will wipe every tear from their eyes.
There will be no more death."
Revelation 21: 4

I am conscious that there have been many casualties in these past few months. It has been an unseen war we have been fighting and I know it has been an emotional rollercoaster as those around us have lost dear ones. Some to the virus itself; some to other causes and diseases. Many have been deprived the chance to be with loved ones when it mattered.

The poppy is a symbol of remembrance, first used in World War I, representing the poppy fields of Flanders, where many soldiers lost their lives. However the bright scarlet colour also signifies a promise of resurrection after death. Let us pause and remember those who have gone before us. They made our world a richer place.

But let's also remember that there is hope. Death isn't the end if we put our faith in Jesus, who defeated it, so that we could have eternal life.

Day One Hundred and twenty

"Do not despise these small beginnings." (NLT)
Zechariah 4: 10

On our windowsill is a jar of sourdough starter. It has been faithfully fed every day but when making the bread itself, the outcome has not been what we expected. Despite carefully following instructions, the first attempt was thrown away; the second totally inedible and the third was palatable but so heavy and the crust rock hard. However the fourth attempt, as pictured, was much better. It wasn't perfect but it tasted pretty good. The fifth loaf is being prepared and I am sure it will get better as we progress.

This Bible verse teaches us not to despise or be discouraged by the small and ordinary things. Any process has to start somewhere. Let's rejoice in the little steps we make. As we do our faith grows as we see progress.

The great artist Vincent Van Gogh said this: *"Great things are done by a series of small things brought together."* So let's rejoice in the small things and the fact we have started.

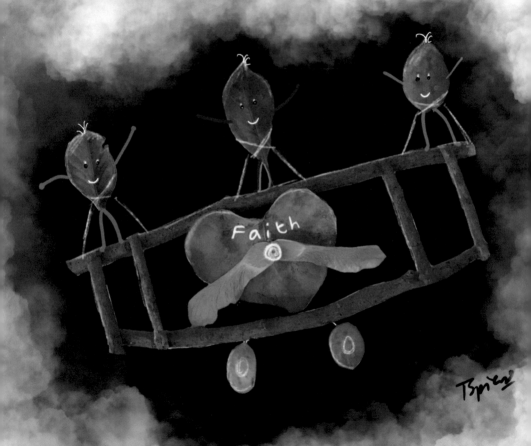

Day One Hundred and twenty one

"I have come that they may have life, and that they may have it more abundantly." (NKJV)
John 10: 10

Almost 20 years ago I covered a story for the BBC about a couple who decided to get married whilst wing-walking 1,000ft above the ground. The vicar was strapped to the middle and the bride and groom were attached to either wing. It would have classed as a socially-distanced wedding today. When they landed and interviews were finished, the wing-walking team approached me and asked if I would perhaps consider training in such aerial antics.

Being the right build I guess it is something I could consider in my latter years when I forget I don't like heights! But what an exhilarating feeling it must be to soar through the air at speed and see the amazing landscape below. If we let it, our Christian walk is supposed to be an thrilling adventure as we go with the promptings and nudges, take steps of faith into the unknown and let go and let God. I may not wing-walk in the physical, but I want to wing-walk in the spiritual sense and be outrageously adventurous.

"God has a constantly flowing
river whose sparkling streams
bring joy and delight to his people."
Psalm 46 : 4

Day One Hundred and twenty two

"God has a constantly flowing river whose sparkling streams bring joy and delight to his people." (TPT)
Psalm 46: 4

I love the sound of a bubbling brook and watching fast flowing water move easily over rocks and pebbles in its path. My children used to enjoy building dams to try and stop the flow of a local stream, but inevitably, the water always made a way to get through.

I have always wondered what this verse means. It reads differently in different translations and I have used The Passion Translation as it helps unpack it. I believe that like a life-giving river, God wants to bring joy and refreshment to us. Often obstacles such as unbelief, doubt, fear, selfishness and pride stop that flow.

He longs to bring tranquility, peace and a sense of security, but unless we remove the stones in the way, we won't receive the fullness of that beautiful river.

Day One Hundred and twenty three

"Take full advantage of every day as you
spend your life for his purposes." (TPT)
Ephesians 5: 16

When I had my first mobile phone it was the size of a brick and it was used purely as a phone, to ring people mainly when I couldn't find the place I was going to. Fast forward 25 years and the mobile phone is like another limb on our bodies as it is permanently attached to our hand or ear.

We use it for listening to music, catching up with documentaries, podcasts, television series, playing games, texting, direction following, finding out information, emailing or zooming friends and colleagues. In fact if we lose it, we are lost. Often our eyes are so focussed on it, we forget to engage with those around us and we miss so much.

Now as lockdown lifts, our High Streets look like a snakes and ladders board, with arrows to follow and circles to step onto. We have to look down to ensure we walk in the right direction. Let us *not* forget to look up and see the wonders around us or allow our phones to become such a distraction that we forget what *is* important.

"Take delight in the Lord, and he will give you the desires of your heart".
Psalm 37:4

Day One Hundred and twenty four

"Take delight in the Lord, and he will give
you the desires of your heart."
Psalm 37: 4

My final thought in this series happens to fall on
Independence Day - celebrated from 1776 to the present
day as the birth of American independence. Usually there
are festivities such as fireworks, parades and concerts as
well as more casual family gatherings and barbecues.
However a pandemic makes such celebrations more
difficult. A few months ago many of us lost our personal
independence as restrictions prevented us from doing what
was normal to us. As I write, whilst life is not what it was,
a certain amount of independence has been given back to
us. Yet there remains a longing. We are designed to love in
a tactile way, so not being allowed to hug the ones you love
has been the hardest part of this season.

However when our will is in line with His, I know desires
are fulfilled. It is God's heart for us to love each other
fully. So let's be in faith that soon we can celebrate with an
International Hug Day.

To take a leaf out of someone's book means to imitate someone; to follow someone's example.

The Good Book is of course the Bible.

About the author

Tracy Spiers is an experienced writer and illustrator who uses her playfulness and sense of fun to communicate in an engaging way. She has worked in all fields of media including many years with the BBC where she was known as the 'and finally' reporter for her endless quirky stories.

She lives in the Cotswolds with husband Rog and is a modern Mrs Bennet to five delightfully different daughters.

Tracy is passionate about helping people and communities discover or rediscover their true heritage and identities. She is also author of several history books for primary schools.

For more information visit: www.tracyspiers.com

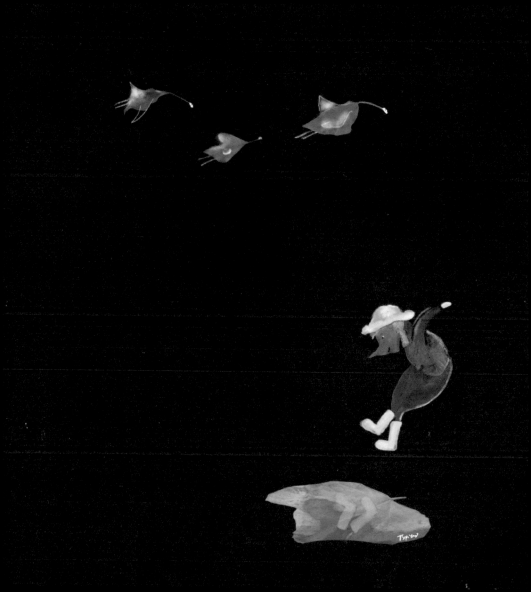